John Panting

Sculpture in fiberglass

The use of polyester resin and fiberglass in sculpture

Watson-Guptill Publications, New York

in association with the Royal College of Art

First published in the United States of
America 1972 by Watson-Guptill
Publications, a division of Billboard
Publications, Inc., 165 West 46 Street,
New York, N.Y., in association with the
Royal College of Art, London.

First published in Great Britain 1972
by Lund Humphries, London

Manufactured in Great Britain
First Printing, 1972

General editor:
Herbert Spencer RDI DrRCA
The diagrams are by Clive Crook.
Frank Thurston took the photographs of
moulds and works in progress
by Gerald Peckham, John Alder, and
Stephen Furlonger.

Library of Congress Cataloging in
Publication Data

Panting, John
Sculpture in fiberglass
1. Plastic sculpture. I. Title.
NB1270.P5P3 731.2 72–2884
ISBN 0–8230–4672–9

Contents

Glossary of British terms for U S readers

Accelerator	British readers may have to add accelerators to resins, but most American resins already contain accelerator, which is added by the manufacturer. Only a catalyst must be added by the sculptor.
Acetate	cellulose acetate.
Aerosil	U S equivalent is Cab-o-Sil (brand name).
Bandage	U S equivalent is Pariscraft (brand name), a gauze that contains plaster.
Bondapaste, Tetrasyl	U S readers should use polyester automotive body paste, sold at automotive body repair shops.
Damp	moisture.
Dufaylite	resin-impregnated paper honeycomb.
Evostick	contact cement.
French chalk	powdered chalk.
Galvanite	cold rolled galvanised steel sheet.
Glass-fibre	fiberglass (U S brand name is Fiberglas).
Glass paper	fine sandpaper or other abrasive paper.
Hessian	burlap.
Joins	joints.
Kerocleanse and Swarfega	detergent jelly.
Meths	methyl alcohol.
Pad-saw	coping saw.
Plasticine	plastiline.
Polythene	polyethylene in sheet form.
PVA	polyvinyl acetate.
Scrim	lightweight, loosely-woven, burlap.
Sellotape	U S equivalent is Scotch tape (brand name).
Turps-substitute	American readers are advised to use turpentine.
Vina-mould	American readers are advised to use hot melt vinyl chloride.

Introduction

These notes are intended to assist the sculptor wishing to use polyester resins and glass-fibre either for casting sculpture or for making it direct. It is in no way intended to replace the various data sheets put out by manufacturers of these products, but should be used in conjunction with them. These data sheets generally contain information about the specific properties of particular resins, glass-fibres and other materials. However, most of this information is of a highly specialized nature and is more applicable to production techniques used in industry. These notes are applicable where sophisticated equipment is not available and where working conditions are not constant. Although the products of various manufacturers may be coded differently, there are a number of general terms in use. These and the materials and processes they describe are listed and will be used throughout these notes. As many of the technical processes overlap and many of the materials used are common to a number of processes, a general note on casting and the two main materials (resin and glass-fibre) will be followed by a more detailed description of the various materials and techniques.

In most handbooks on methodology, clarity is generally achieved by instancing specific examples of common types. As it is not possible to speculate with much accuracy on the exact nature of work that might be undertaken by a contemporary sculptor, the diagrammatic examples have been severely simplified, and to cover the exigencies of casting various types of forms/shapes it may be necessary to take note of features mentioned in two or more examples. The photographs are not intended as illustrative examples of strict procedure but rather to supplement the diagrams in an illustrative way.

Polyester resin and glass-fibre

Polyester resin is a liquid made from unsaturated alkyds with a reactive monomer (styrene). The addition of a catalyst (an organic peroxide) develops a polymeric reaction which changes the resin from a liquid to a solid, hard plastic. This process, known as *curing*, is effected in two ways – either by the external application of heat or by the addition of an accelerator (e.g. cobalt napthanate) which reacts with the catalyst to produce an exothermic reaction which provides 'internal heat'. (This reaction can be quite violent and extreme care must be taken to see that the two chemicals are never mixed directly.) The second method, known as *cold curing*, although it may be used in conjunction with external heat, is the more practicable and the most suitable in the production of castings, etc. for sculpture.

Curing takes place in four stages. In a rapid cure the stages are clearly discernible. After catalyzation the resin changes from a syrupy free-running liquid to a soft gelatinous state (*gelling*). A gel may form a few moments after the addition of the catalyst but may take hours or even days; the time depends on a number of factors, such as the amount of catalyst, type of mould, and ambient temperature. After gelation, the cure is propagated by the application, or in the case of cold curing by the evolution, of heat; this exothermic reaction is also variable in terms of temperature and duration. When the cure is complete, the resin is hard and tack-free. In general, the conditions which affect the curing of polyester resin are those which affect the heat generated or applied; the greater the heat the faster the cure. *Remember* that in using accelerated resin the degree of exothermic reaction that takes place also depends on the bulk of resin, so that in cases where large amounts of resin are

allowed to gel the heat produced may exceed the heat required, and this may cause cracking and in extreme cases self-ignition. Similarly very small amounts of thin layers of resin may be unable to build up sufficient exothermic heat and the application of external heat may be necessary to complete the curing process. There are many types of polyester resins, made for a variety of specific purposes. Generally the discernible differences are in viscosity and colour. Each type will be described in the section appropriate to its use.

As cured polyester resin has little structural strength, it is generally used in conjunction with a reinforcing of glass-fibres or 'fibre-glass' (the trade name of a firm producing this material). Glass-fibre comes in a variety of forms suitable for use by the sculptor. Two types predominate – woven glass fabric and chopped strand mat. Woven glass fabric, as its name implies, resembles an ordinary woven fabric. It gives the greatest mechanical strength, but is generally less adaptable and more expensive than chopped strand mat. Chopped strand mat consists of filaments of glass-fibre cut into 2 in. lengths, bonded together with a medium that dissolves when liquid resin is applied to it. Chopped strand matting is therefore extremely easy to manipulate and its use is generally satisfactory for most sculptural casting. The glass-fibre mat/cloth is impregnated with catalyzed resin and provides a rigid reinforced casting material. Each type of glass-fibre fabric will be described more fully in the section dealing with its use.

Hand lay-up casting process

The most common method of using polyester resin and glass-fibre is the hand lay-up process of casting. For this reason, and because many of the subsequent techniques described derive from the process, it will first be described generally, and then a more detailed description of the materials will be given, followed by a breakdown of the procedures involved.

The process is used to obtain a glass-fibre reinforced polyester resin cast from either a male or female mould. The mould can be made from a wide variety of materials – plaster, wood, sheet-metal and others. It should be suitably sealed and the casting surface treated with a release agent (separator). When the release agent is thoroughly dry, the lay-up process may be started. An even gel-coat is applied to the mould surface and allowed to cure to a firm, almost tack-free condition. A laminating resin is then applied to the surface and a suitable form of glass-fibre matting, pre-cut to size, is laid on the top of the still liquid resin. The remainder of the laminating resin is then stippled on to the mat until the mat is thoroughly impregnated. When this is completed, other laminates can be added until the cast is of the required thickness. The cast is then left to cure completely before it is removed from the mould.

Hand lay-up casting process

General programme

1. Prepare mould (seal, polish and apply separator/release agent).

2. Prepare mat, i.e. cut to size sufficient for the total number of laminates.

3. Catalyze gel-coat and apply to mould.

4. Catalyze laminating resin and apply to mould.

5. Place mat in mould and apply remainder of laminating resin.

6. Repeat 4 and 5 according to number of laminates required.

7. Trim excess mat from mould edges.

8. When cured, remove cast from mould.

The procedures: a breakdown

Preparing the mould

To obtain a good cast, it is very important to prepare the mould properly and it is worth spending some time on this. Polyester resin is a highly tenacious adhesive and correct sealing and separation are essential to facilitate the removal of cast from mould. Assuming that the mould has been correctly made, the following points must be observed for moulds constructed of the various materials:

Plaster: The mould must be absolutely dry. Evaporation of moisture from the back of a damp plaster mould produces a cooling effect and curing may be delayed and a tack-free cast surface be impossible to obtain. Damp in the mould will not allow the shellac sealer to adhere properly, moisture will accumulate in the mould and prevent the water-soluble PVA separator from drying completely. The dry mould must be sealed. This is most easily done by applying two to four coats of shellac (button polish). The sealer must not be allowed to collect in corners or hollows in the mould. When an even gloss finish has been achieved and the sealer is dry, the mould should be waxed and polished. There is a variety of special wax preparations for this purpose. An ordinary household furniture or floor wax, however, will do, although if the cast is to be painted subsequently the use of silicone wax is best avoided. In a heavily textured mould it is often difficult to apply wax evenly or to polish off excess wax. It is advisable in such cases to thin the wax slightly with turps-substitute and apply sparingly with a paint-brush with fairly firm bristles, taking off the excess with a dry brush of the same type. When the polishing has been completed, a suitable release agent should be applied evenly to the mould surface. If this tends to collect in globules on the surface, dusting lightly with french chalk will ensure even adherence. Wax emulsion-type release

agents should be applied with a piece of damp soft cloth. PVA release agents are best applied with a sponge. Where the mould is heavily textured a soft brush can be used. For certain types of plaster moulds a specially formulated release agent that requires no prior sealing may be used (see Release agents, page 75).

Wood: Basically the same procedure as for plaster moulds, although cellulose primer-surface can be used to seal the surface. Wax polish well. PVA or wax emulsion release agents can be used.

Metal: Moulds made of metal require no sealing, and if the surface is extremely smooth waxing can be omitted. An even application of PVA release agent is essential.

Glass-fibre and polyester: No sealing required, but the mould should be well waxed and polished. PVA or wax emulsion release agents.

Vina-mould or latex compound: The mould requires no sealing, waxing or release agent. But some vina-moulds need a thin application of PVA release agents if a slightly tacky surface is to be avoided.

Melamine or formica: No sealing required. If the surface is in good condition, no waxing is necessary, but it is better to wax if the surface is scratched. PVA or wax emulsion.

Glass: No sealing. Waxing and polishing advisable. PVA or wax emulsion. In casting from moulds made of polythene, polypropylene or acetate, no preparation is necessary.

The procedures: a breakdown

Cutting the mat to size

Choose an appropriate type and weight of mat. Cut enough mat to cover the mould the desired number of times. For ease of lay-up, it is normally best to keep the mat in as large pieces as possible. Paper patterns may be cut first. This prevents wasteful usage of mat and makes for easier handling. Where the mould to be filled is very complicated, the mat may be torn or cut into small squares. Allow for an overlap of a half-inch or so on the joins and round the edges.

Gel-coat application

Select the right gel-coat, decant a convenient working amount, catalyze, and apply evenly with a soft brush. As the gel-coat constitutes the exposed surface of the final cast, every care must be taken in applying it. Avoid uneven build-up of gel in hollows and corners of the mould. In complex or heavily textured moulds, the position of the mould may have to be changed to prevent gel from gathering in these places.

Laminate application

When the gel has cured to a firm, but not completely tack-free, condition, the laminating resin and glass-fibre may be applied. A suitable quantity of laminating resin should be catalyzed and brushed over the gel. The pre-cut mat should then be laid carefully into the mould on to the still liquid resin. Next, the remaining laminate should be brushed on to the mat and stippled into it until the mat is thoroughly impregnated; it should be left to cure to a reasonably firm condition and excess mat should be trimmed from the edges of the mould. This process can be repeated until the necessary number of laminates is obtained. In simple moulds where there are no steeply inclined surfaces, heavy textures and

The procedures: a breakdown

so on, subsequent layers of mat can be applied without allowing partial cure between times. Before the cast is cured hard, any reinforcing necessary should be done. The cast should then be left to cure in the mould until a hard tack-free surface is obtained. This state does not necessarily indicate that the curing is complete, so the cast should be left in place for as long as possible to avoid later warping and other changes.

Removal of cast

When the cast has cured, it may be removed from the mould. Waste plaster moulds should be slipped off with care; excessive hammering may craze the surface or even fracture the cast. Casts from smooth moulds can be eased out gently. Where there is no provision in the mould for the use of compressed air or knock pins, a little water allowed to seep between the surface of mould and cast from an exposed edge will facilitate removal. With some reinforced resin or metal moulds a slight flexing of the mould will also help.

Joining and finishing

If the cast is one of several parts of a complete job, edges should be trimmed and dust and particles should be removed. The pieces should be taped or bolted together in the position to be joined. The joint should be effected by brushing resin over the seam and applying a laminate of one or two layers of mat sufficient to overlap the gap between the two edges by at least one inch on each side. (For more detail, see Joining methods, page 93.)

The procedures: a breakdown

The completed job can be finished in a variety of ways. If coloured resin: have been used, it may be unnecessary to apply any additional surface layers, such as paints. In these cases, the seams are cleaned off with files, wet and dry abrasive papers or similar means and the cast surface can be taken to whatever stage finish is required from a matt worked surface, i.e. file marks, etc. may be utilized, to a high gloss polish. If the surface is to be subsequently painted, the seams should be cleaned off and all traces of release agent and mould wax should be removed. If the surface is not to be worked on, the cleaning can best be done by washing with warm water with the additional use of fine 360 grit wet and dry. If the surface requires complete reworking, special attention need not be given to the removal of release agent, etc. All patching necessary should be done by using a filler resin before the first coat of primer paint. (For more detail, see Finishing methods, pages 101–9.)

Typical sequence of hand lay-up process into mould.

The procedures: a breakdown

Apply release agent . . .

gel coat . . .

glass-fibre mat laminate . . .

trim laminate . . .

remove from mould . . .

assemble

Gel-coating and laminating

Gel-coating procedure

The gel-coat procedure, after applying barrier cream to your hands, is:

1. Estimate quantity of resin required, allowing $1\frac{1}{2}$ to 2 oz per sq.ft. Weigh into plastic container.

2. Stir in additives (if any).

3. Use the nomograph to determine the volume of accelerator required. *Mix thoroughly*. If a test mix is required, decant a small quantity of this resin now, add catalyst, and give time to gel.

4. Determine volume of catalyst necessary. *Mix thoroughly*.

5. Spread gel-coat evenly over mould surface. Avoid aeration and where possible any undue build-up of resin in hollows.

6. Clean brush in Kerocleanse and/or hot water and detergent.

7. Clean up any spilt resin now – before it hardens.

The minimum permissible time between the first gel-coat and backing coats is about thirty minutes, i.e. when it is quite firm but still retains a slight surface tackiness.

Heat is generated by the reaction of accelerator and catalyst during gelling. This heat tends to build up in a body of resin. So:

1. *Never mix neat accelerator and catalyst together*.

2. Avoid excess deposits of resin wherever possible, i.e. build up the thickness layer by layer.

3. Note that the resin will tend to gel most quickly where it is in bulk, i.e. container before mould, so *first* spread catalyzed resin, then stipple it through the glass mat.

4. *Never* leave surplus catalyzed resin unattended. Should heat build up excessively, douse in water.

Laminating procedure

Apply barrier cream to your hands.

1. Weigh pre-cut glass mat. Double this weight to find the quantity of resin required. Weigh into plastic containers.

2. Mix in additives (if any).

3. Use nomograph to calculate volume of accelerator required. *Mix thoroughly*.

4. If the total weight of resin exceeds 5 lb, decant this quantity, calculate the volume of catalyst required and mix thoroughly.

5. Brush a light coat of this resin on to the back of the hardened gel-coat. Place pre-cut glass mat into position and stipple further resin through the mat, using a brush or roller. Avoid air bubbles – betrayed by whitish patches. Brush the laminate well above the sides of the mould ($\frac{1}{2}$in.).

6. Second and third layers of mat may be carefully placed and laminated in position without delay. *If the resin begins to gel, stop immediately, clean brush, re-mix and continue*.

7. Add any reinforcing ribs, struts or fixing bolts that may be necessary. Laminate them in position.

8. Clean brush in Kerocleanse and/or hot water and detergent.

9. Clean up stray resin *now* before it hardens.

Gel-coating and laminating

In the laminating procedure, as in gel-coating, heat is generated by the reaction of accelerator and catalyst during gelling. This heat tends to build up in a body of resin. So:

1. *Never mix neat accelerator and catalyst together.*

2. Avoid excess deposits of resin wherever possible, i.e. build up thicknesses layer by layer.

3. Note that the resin will tend to gel most quickly where it is in bulk, i.e. container before mould, so first spread catalyzed resin, then stipple it through the glass mat.

4. *Never* leave surplus catalyzed resin unattended. Should heat build up excessively, douse in water.

Hand lay up from a heavily textured plaster waste mould.

1. Sealed waste mould ready for application of release agent.

2. Applying release agent with soft brush.

3. Applying release agent with soft brush.

4. Mixing gel coat.

5. Application of pigmented gel coat to mould with brush.

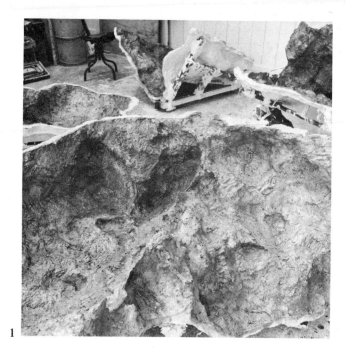

1

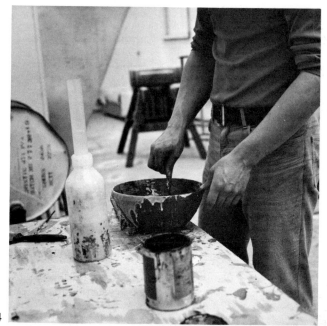

4

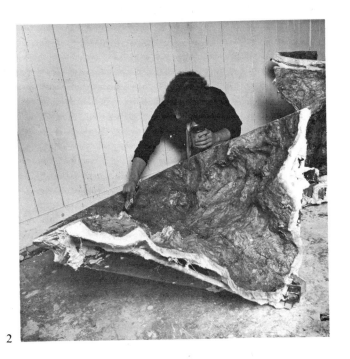

2

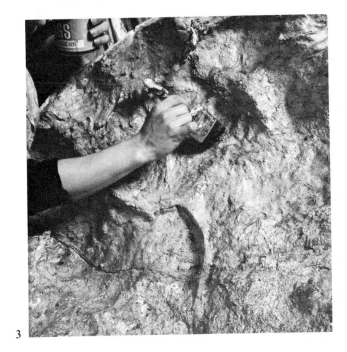

3

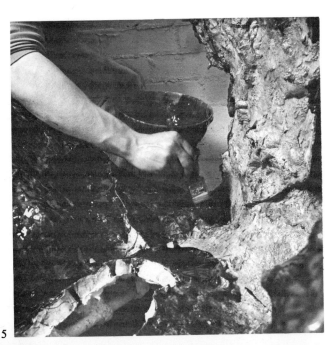

5

21

1. Application of a mixture of chopped strand mat and laminating resin to even out awkward indentations in the mould.

2. Application of chopped strand laminate to the mould.

3. Mould surface showing laminate complete.

4. Removal of the waste mould.

5. The completed laminate ready for final cleaning and trimming prior to assembly.

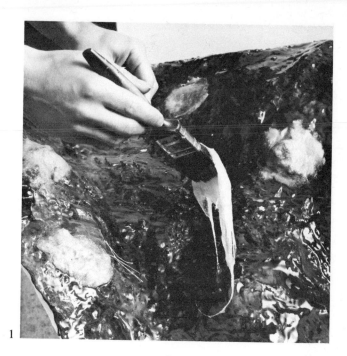

1

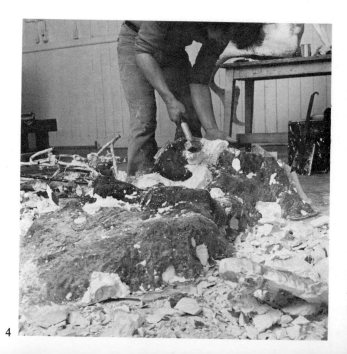

4

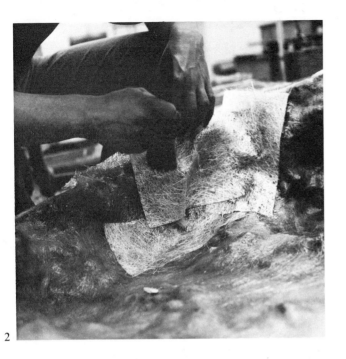

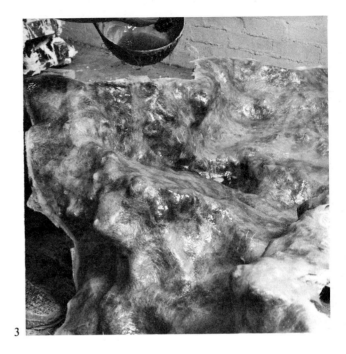

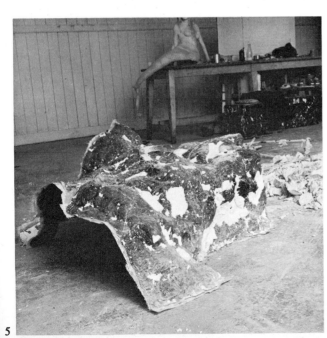

Precautions

Polyester resin and glass-fibre are convenient and suitable materials for the sculptor, but they are not pleasant to handle and may in some cases be highly dangerous. Some simple precautions taken whenever these materials are used will ensure that the user comes to no harm. They may appear irksome at first but it is worth while taking the trouble to make them habitual.

Many people observing work in industry gain the impression that few precautions are taken in the handling of these materials. They tend to forget that industrial techniques are usually split up into different tasks so that one operator has to deal with one aspect only of the work; precautions taken appertaining to one job are not likely to be glaringly evident. The sculptor/caster has to undertake many such tasks – and usually in much less sophisticated surroundings. So here are a dozen, vital dos and don'ts:

Always ensure that there is adequate ventilation when you are casting or using polyester resins. Where this is impossible, for instance when assembling a large cast or working inside a mould, wear a respirator with a chemical filter. An old gas mask is ideal and not too much of a hindrance.

Always use a barrier cream when handling resins or glass-fibre or wear protective gloves. The resin and glass-fibre are irritants and may cause dermatitis.

Precautions

Always wear a cloth filter mask when dry-sanding, cutting or filing cured resin. Apart from the dangers of inhaling an insoluble solid, most cold-cure polyester resins are chemically active for up to thirty days after gelation. Resin and glass-fibre dust is a 1:2 ratio of *glass* to resin. Ponder this.

Always keep catalyst and accelerator and resin away from naked flames and other heat sources. Burning catalyst produces oxygen-high vapour which ignites and burns.

Always wash spilt catalyst or accelerator off your hands immediately. Organic peroxide is an extremely efficient oxidizing agent and will cause severe burns.

If you get resin, catalyst or accelerator in your eyes, flush copiously with cold water. Visit a doctor.

If catalyzed resin in bulk starts cracking, smoking or getting excessively hot, douse in cold water.

Never mix neat accelerator and catalyst together.

Never leave catalyzed resin in containers or in any bulk unattended. The exothermic reaction may ignite it.

Never smoke while using resins.

Precautions

Never tip large amounts of catalyzed resin into a waste bin. If it is necessary to abandon some, spread it out on a polythene sheet so that the exothermic heat is dissipated rapidly.

Never use *hot* water to remove cured resin dust from hands, face and other parts of the body. Use cold or lukewarm water. This stops particles of dust getting lodged in the pores of the skin and causing irritation.

Basic equipment and tools

The necessary equipment and tools are: containers for mixing resins, brushes, scissors, laminating rollers, trimming knife, filling knife, stripping knife, pad-saw, plastic fillers, surform, files, wet/dry abrasive papers, and wire brushes for cleaning files.

All these are articles in fairly common use and all but the laminating rollers are likely to be in use for other purposes. However, some special points are worth noting.

Containers

Containers should be of flexible polythene. Buckets are best for pre-mixing resin and small bowls for mixing working quantities. Flat basins tend to make even mixing more difficult. A number of plastic containers manufactured for other purposes can easily be adapted for casting. Disposable wax-paper cups are also extremely convenient where only small quantities of resin are being used. It is not advisable to use containers of metal or other inflexible material; it is hard to get old resin out of them.

Brushes

Any paint brush will do for applying resins, laminating, or gel-coats. However, a number of firms make cheap brushes specially for these purposes and their use is recommended. Always use a brush big enough for the job; the largest possible is a good rule. Don't use stiff bristle brushes.

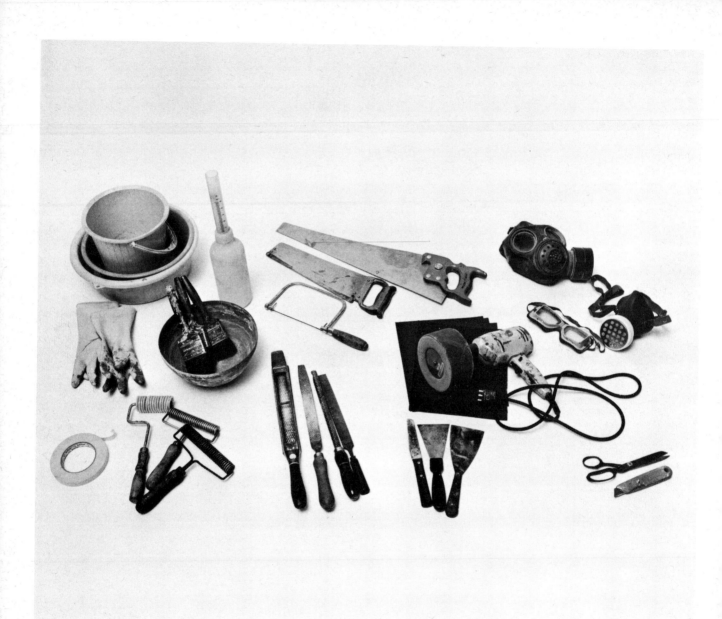

Cutting tools

Scissors may be used for cutting glass-fibre chopped strand mat or cloth. However, if a flat wooden surface is available, it is more convenient to lay the mat on it and cut round it with a Stanley knife or similar tool. A Stanley knife is also useful for trimming the partially cured excess mat from mould edges, although a more convenient tool for this purpose is a sharpened stripping knife about 3 in. wide. A pad-saw or coping saw may be used if the impregnated excess mat to be trimmed has been allowed to cure. An old panel saw is a luxury for cutting resin, as it requires frequent sharpening; but on jobs where long and even cuts have to be made it is a great asset.

Rollers

Two kinds of rollers are used for applying gel coats and aiding thorough impregnation and consolidation of mat. The first type is in general identical to mohair paint rollers. The second is made of either nylon or steel washers. The steel washer kind is easy to make and maintain; old resin is simply burned off. A variety of sizes is available. The length of the roller used depends on the surface to be rolled. Surfaces undulating in more than one direction require short rollers; for other surfaces the best general rule is – as large as possible.

Files

Surforms are good general-purpose tools for working cured resin, cutting back excess filler, and similar work. Ordinary files can be used but they tend to clog rather quickly; dreadnought files are better.

Abrasive papers

Because of the danger of inhaling glass-fibre and resin dust, glass paper should be avoided where possible. It is useful to have a variety of wet/dry paper for all types of finishing work. For working flat surfaces, wet/dry may be stuck to chipboard or similar bases to facilitate the removal of irregularities.

Power tools, drills

Metal twist drills should be used for drilling cured glass/resin castings. There are a number of power tool fittings suitable for use, such as disc and drum sanders for edges. However, because of the large amount of dust from most power tools, they should not be used in areas with poor air circulation. Masks and goggles should always be worn. A jeweller's metal saw, used in conjunction with a flexible drive, is invaluable for trimming curved edges and has many applications in the making of sculpture *direct*.

Casting surfaces

An essential piece of equipment for making up flat surfaces in sculpture is a flat casting table, which is useful in levelling casts and for other purposes. A casting surface must be free from twists, durable and reasonably scratch-resisting. The choice is from:

1. Glass-topped table – glass, insulation board, extremely fragile, superlative surface from which to cast. Glass must be at least ¼in. plate; check old glass for surface irregularities.
2. Galvanite-topped table – galvanite laminated to chipboard, inexpensive medium type surface, scratches easily.

3. Melamine surface – chipboard/blockboard/formica – best all-round table surface, scratches fairly easily, can be cleaned with fine 600 wet or dry to even slight scratches.

Filling knives

A filling knife is essential. A slightly less flexible stripping knife may be preferred, and the same knife, well honed, can be used for trimming excess mat from moulds. A 3 in. blade is the most useful general-purpose width for applying stopper (cellulose or synthetic) or filler pastes to shallow indentations and seams. Polythene filler spreaders are also useful. Small pieces of hardened tempered steel about 0·02 in. thick are very convenient to use when filling convex surfaces. At about 25p for 10 ft \times $1\frac{1}{2}$in. this is a really worth-while buy. Small lengths can be snapped off and used as required.

Making the mould

Suitable moulds for polyester resin/glass-fibre casting can be made from plaster, polyester/glass-fibre, metal, wood, cardboard, hardboard, vina-mould and other latex moulding compounds, glass, formica, melamine, chipboard etc. The main requirements, as noted earlier, are that the mould should be entirely free of moisture and its surface suitably sealed and treated with an appropriate release agent. Other important factors must be considered, some relating to mould making in general and others more particularly to polyester resin/glass-fibre casting. The selection of a moulding material is obviously dictated by the job in hand; a description of the various materials and methods for using them follows. It is, however, difficult to list all the factors involved in a casting job and the user is advised to familiarize himself with all the methods and thoroughly consider them.

Plaster moulds

The use of plaster in polyester resin casting is sometimes ill-considered. Plaster is unsuitable where more than one cast from each mould is required, it dries slowly; a thick cast may take weeks to dry enough to cast from, and rapid drying by applied heat often causes warping. Because it is mainly used for making waste moulds, there is a tendency, in the effort to save time, to take less care in using it. The economy is a false one.

The following rules should be carefully observed:

Plaster moulds should *in general* be made as thin and even as possible. This facilitates drying and minimizes warping. Edges arising from

Making the mould

divisions in the mould should also be as clean and even as possible, for easier trimming.

Sealing with shellac and a subsequent release agent treatment of wax polish and P V A separator – rather than the use of a wax emulsion release agent requiring no sealing – give maximum scope for alterations that may be made to the mould, filling unevenness in the surface for example, and generally give easier cast release.

Always ensure that the individual pieces of a plaster mould are of such size and shape that easy access is permitted for casting; avoid having high vertical surfaces which tend to overhang. It is easier to make more pieces than waste time and effort trying to laminate into a mould with difficult access. Try to arrange the seams in the mould so that they traverse areas which are easy to reach with a file or other abrasive tool on the final assembled cast. Often, when piece moulds are made, to facilitate removal from the positive several pieces may be joined before casting begins, provided they do not hinder the laminating process.

When casting from clay positives, use preferably brass shim as a dividing wall between mould pieces; it gives a cleaner edge from which to trim excess mat. If there is any texture on the surface, the application of a coloured 'first coat' will make the task of chipping out easier. The over-all thickness of the mould section should not exceed $\frac{1}{2}$in. and, unless the positive is free from texture, no reinforcing should be used in the mould itself. Wood or iron reinforcing rods should be attached to the completed mould with scrim and plaster before removal from the clay

positive. A little thought when attaching these will ensure that the mould has a firm support that will cradle it during the laminating process. After removal from the positive the mould should be cleaned by washing and reassembled to dry.

When casting from plaster and other rigid positives (which involve the making of a piece mould), moulds can be thinner and contain reinforcing, since they will not have to be chipped off. Clay dividing walls

Example of lightweight plaster moulding using plaster-impregnated bandage instead of scrim.

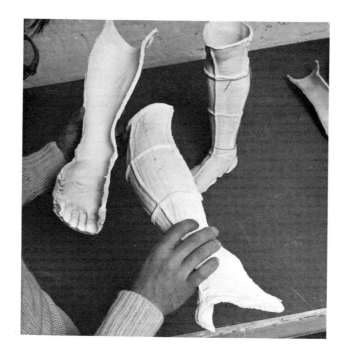

should be used; make these as even and smooth as possible and about $\frac{1}{2}$in. proud of the surface of the positive.

To make a mould as thin as possible, a method which is a little unorthodox and requires great care but does produce an extremely light, quick-drying mould is recommended. Plaster or other porous positives should be sealed with several light coats of shellac.
The procedure is as follows:

1. Fix clay wall in place.

2. Oil surface of area within the clay wall with rape seed oil.
(Apply the oil lightly with a brush or soft cloth.)

3. Cut hessian scrim to fit the area. A loose-weave hessian should be used, i.e. with squares of about $\frac{1}{4}$in. formed by the strands – a closer weave is *not* suitable.

4. Mix enough plaster to apply a normal 'first coat' at a smooth, creamy consistency.

5. Gently apply the plaster to the positive surface either by hand or by brush until an even layer covers the surface about $\frac{1}{8}$in. thick.
If the oil repels the plaster, a light rubbing with the hand will effect adhesion.

Making the mould

6. Lay the hessian on top of the still unset plaster and lightly rub it, adding more plaster (of the same mix) until the hessian is evenly covered. The mould at this time will be just over ⅛in. thick. The hessian should be rubbed just heavily enough to imbed it in the plaster – care should be taken not to push it through to the surface of the positive.

7. Add the remainder of the plaster to the edges of the mould piece, i.e. over about 1in. Taper the thickness of the mould up to the height of the clay wall.

8. If the piece needs additional reinforcing, this may be done with plaster and scrim ribs applied immediately or light wood reinforcing tagged on with scrim when the mould is complete but *before* removal from the positive.

Two coats of plaster may be applied, i.e. first one minus scrim, if the surface is uneven and there is a likelihood of the scrim being pushed through to the surface. However, one coat where possible is better and minimizes the chances of warping.

The method described is not suitable where it is intended to carry out smoothing or other additional work on the mould. Where this is the intention, the plaster *must* be applied in two coats – the first scrim-free and thick enough to allow for the desired amount of smoothing, etc.

The mould can be smoothed with wet or dry paper, when the plaster is

Method of supporting irregular shape moulds.

still damp, or with glass paper when it is dry. Operations such as hole-stopping are best done when the mould is dry and has been sealed with shellac. Holes or uneven areas may then be filled either with plaster or a commercial stopper like polyfiller or cellulose stopper.

Wood and board moulds

Moulds made of wood, hardboard, cardboard, chipboard and similar materials are generally not made from a positive but constructed either in male or female form direct. As in deciding on the shapes of mould pieces for plaster moulding, care should be taken to allow easy access to the mould and avoid overhanging mould surfaces. As with a plaster piece mould from a rigid positive, moulds from wood, hardboard and chipboard must be so constructed that there are no undercuts which would prevent the removal of the cast from the mould. If a number of mould pieces of these materials are joined for laminating, plasticine is best for sealing slight gaps between the pieces. Clay can be used, but because it must be put on before the release agent wax polish and P V A release agent are added, clay may dry out and crack before laminating can take place.

Using casting surface to fabricate
geometric shape.

1. Laying gel-coat on casting surface.

2. Laying down laminate of chopped
strand mat.

3. Placing prefabricated plywood
former on to wet laminate.

4. Spreading the wet laminate to form
a bond with the plywood.

5. Trimming excess laminate.

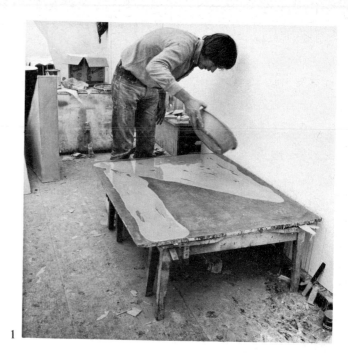

1

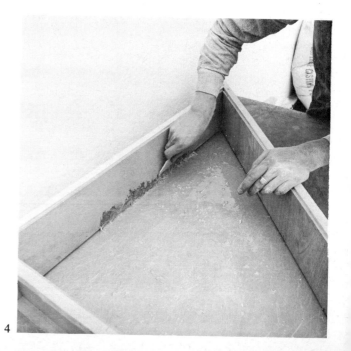

4

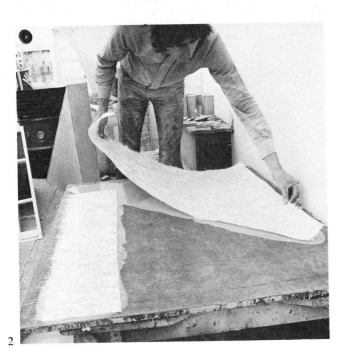

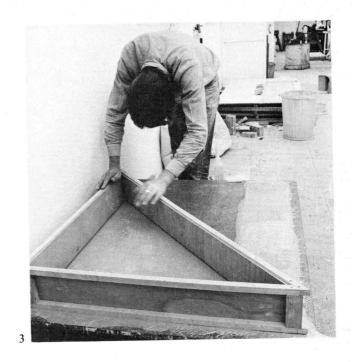

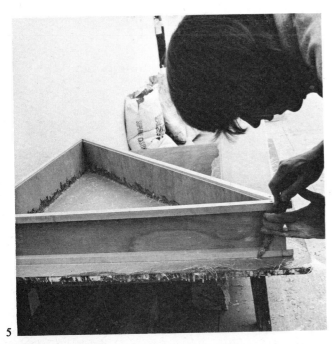

2

3

5

1. Removing excess laminate in its leather hard state.

2. The completed shape, all faces having been completed in the previous manner.

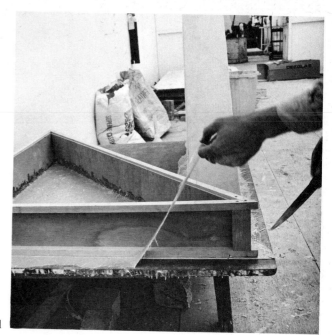

1

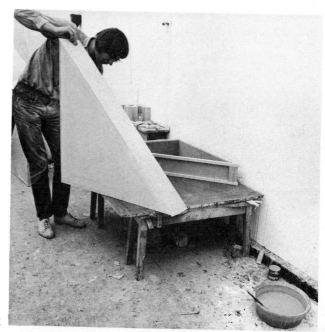

2

Making the mould

For best results, moulds in this category should be sealed with shellac or cellulose lacquers. Some specially manufactured wax fillers can also be used for adding radii to edges and corners and other details which will read as negative shapes on the finished casts. The wax in these fillers has a higher melting point than the exotherm of most ordinary resins. *Remember when sealing a porous mould that most lacquers and paints soften when heated. Make a test to check sealer reliability.* Remember also that moulds made from wood or board may be flexible and may require reinforcing. There are few casting procedures more frustrating than attempting to lay up resin and glass-fibre into a mould that flexes and wobbles. Such moulds also invariably give an inaccurate cast. Resin shrinkage on a cast of average thickness – two laminates $\frac{1}{32}-\frac{1}{8}$in. – will cause a right-angled corner to pull in about two degrees. This may be allowed for either by making right angles slightly obtuse in the mould or by modifying the casting procedure (see Shrinkage problems, page 78).

Typical construction of wood or building board mould.

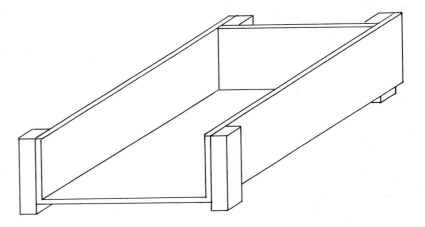

Metal moulds

Metals like aluminium, galvanite (rolled, galvanized sheet steel) and stainless steel provide the ideal casting surface. There are limits, however, to their application. In general they are suitable only for making moulds of a geometric nature, *unless* the user has access to equipment capable of free-forming metal, for instance a wheeling machine, facilities for explosive moulding from plastic positives, or facilities for making cast metal moulds. If any of these are available, then the general rules for making rigid moulds apply. There should be no undercuts on individual mould pieces, and easy access to the mould should be ensured. Moulds fabricated from sheet metal using limited sheet metal working equipment should also allow for these factors. Edges should be folded to form a flange where possible to give additional rigidity. Some shapes are inherently flexible (half-cylinders, etc.) and should be cradled in a wooden support while casting. Thin, flat sheets of metal have a tendency to sag even when they are supported round their edges. They should be supported on a flat, rigid surface. Metal moulds may not be as smooth as they look. To test the surface smoothness of any material rub a piece of

Typical construction and support of sheet metal moulds.

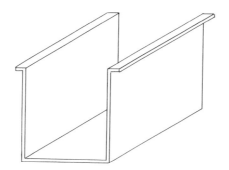

cheese-cloth over it. A 'toothy' surface will catch fibres of cloth. Such surfaces should be rubbed lightly with finest abrasive paper, 400 grit or more, polished and then treated with a P V A release agent. Metal that has a good, smooth surface requires only a thin smear coat of P V A release agent. *Always attempt to make a mould that can be removed from the cast rather than the other way round.* This ensures that the cast is not flexed unduly until it is fully cured.

Incorrect and correct division of mould.

**Polyester resin
and glass-fibre moulds**

This is perhaps the most adaptable moulding material. Basically the same process is used as in casting by the hand lay-up method for the actual laminating of the mould, and the same process to deal with mould divisions and so on as in piece moulding in plaster from a rigid positive. The positive to be cast should be suitably sealed. The position of the various pieces of mould should be planned so that non-adjacent areas can be laminated at the same time. This saves time as it is essential to cure mould pieces firmly before mould walls are removed. Division walls made of plasticine about 1 in. high should be fixed in place. The area within the plasticine walls should be treated with suitable release agents and a normal gel-coat and laminating procedure should be carried out. Care should be taken to cover the inside of the plasticine wall with gel-coat and the gel should be allowed to cure to a really firm state before application and lamination of the mat. After the first pieces of mould laminated have cured firmly, the plasticine walls should be removed and the exposed mould edges (together with the next area of positive to be moulded) should be treated with release agent. Make sure that the mould edges get a really thorough coat. The next area is then gel-coated and laminated and so on until the positive is completely moulded. Holes to take bolts $\frac{1}{8}$–$\frac{1}{4}$ in. thick are then drilled through the raised flanges at the edge of each mould piece. These flanges are then trimmed with a coping saw so that they are about $\frac{3}{4}$ in. high and of a consistent thickness from cross-section. If possible, reinforcing should not be added to glass-fibre moulds. Usually the flange round the mould edges gives sufficient rigidity to make this unnecessary. If large shapes flex too much they should be supported by wooden cradles or frames while the cast is taken After curing is complete, the mould should be removed from the

positive and bolted together. Glass-fibre/polyester resin moulds can be worked on with wet and dry paper; pin-holes in the mould surface, due to filler deficiencies or faulty application, can be repaired with a thick filler paste, such as Bondapaste or Tetrasyl. The moulds should be wax-polished and treated with a P V A release agent before casting.

This method of moulding is useful if a cast is required quickly, since, if the resin is cured really firmly and is well prepared, the cast can be made on the same day as the moulding. This is not recommended as standard practice, however; it is preferable that the mould should be taken from the positive, bolted together and allowed to cure well for several days.

Polyester resin/glass-fibre is not suitable for moulding from a clay or the damp, flexible positive. If it is necessary to mould such a positive so that a number of casts may be taken, it is best to mould and cast it in plaster, then make polyester resin or glass-fibre moulds from the plaster positive.

Latex compound moulds

Techniques employing vina-mould or similar latex compounds are normally suitable for making moulds from which polyester/glass-fibre casts may be taken. Where casting of a very precise nature is required, only the most rigid vina-mould is recommended, as standard vina-mould is inclined, even with a supporting case, to be too flexible to guarantee the reproduction of flat surfaces, straight edges, etc. To avoid surface tackiness on casts taken from a mould made of vina-mould, a smear coat of P V A release agent can be used.

In making flexible moulds using vina-mould the procedure is as follows:

Photographs 1, 2, 3 show a combination glass-fibre vina-mould negative.

Photograph 4 shows how moulds may be slit prior to lay up to facilitate removal of cast from mould. Resin tags at top of slit prevent tearing.

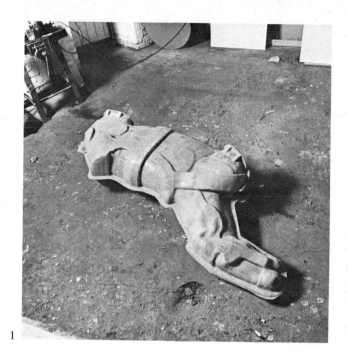

1

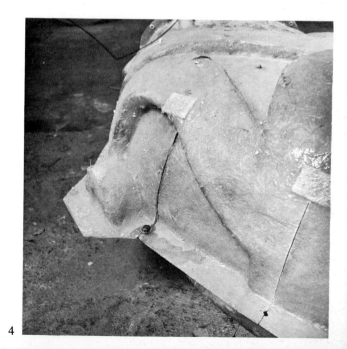

4

2

3

Making the mould

1. Support the object and divide with a clay wall $1\frac{1}{2}$–2in. wide.

2. Cover object with even layer of clay $\frac{1}{2}$–1in. thick. Add pouring and air vents. Cover clay with plaster case approx. 1in. thick – reinforce where necessary.

3, 4. Turn object and repeat procedure on other side. The clay wall should be removed and the exposed edge of the plaster case should be given a coat of clay wash.

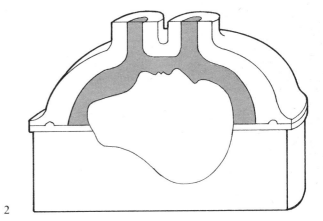

1

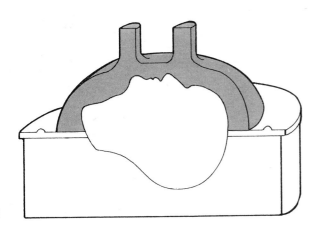

2

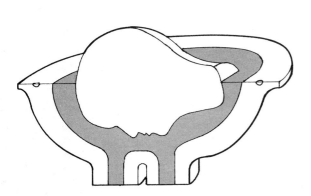

3

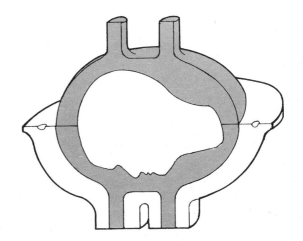

4

Making the mould

5. The external plaster case is complete.

6. Remove one half of the plaster case and remove clay from the same half. Replace case and secure with plaster dogs or string.

7. Pour in vina-mould and allow to set firmly. Turn mould and repeat for other side.

8. The mould may be split and the two halves used for casting.

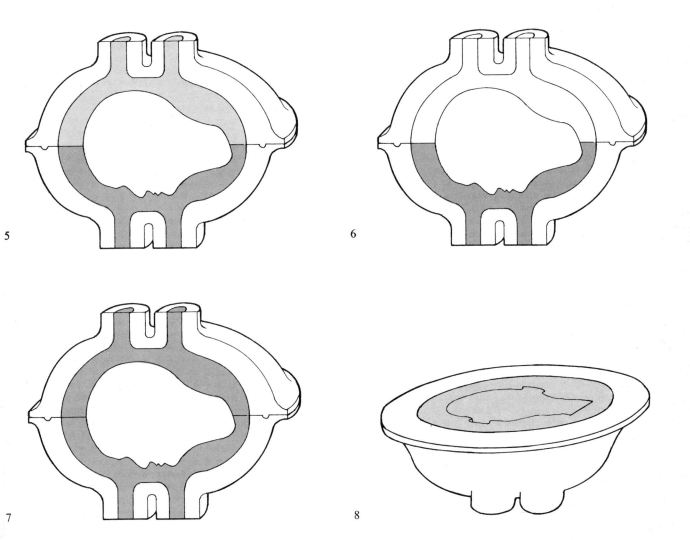

5

6

7

8

Making the mould

It is possible to combine vina-mould technique with polyester resin technique for mould making where a large shape with clusters of intricate detail is to be moulded. The technique is essentially the same apropos the use of clay to provide the cavity to take the vina-mould. This however is confined to the area of detail. The procedure is as follows:

1. Prepare object for making a resin mould – plasticine dividing walls, etc.
2. Cover area with fine detail with layer of clay (1in. thick plus pouring vents).
3. Cover clay with aluminium baking foil.
4. Laminate mould in usual way.
5. Remove mould and clay.
6. Replace mould and pour vina-mould.

This method is useful where several casts are required from a large object with small local areas of detail. It saves time and money – resin being considerably easier and cheaper to use over large areas.

Vina-moulding is particularly suitable for casting heavily undercut and textured surfaces where more than one cast is required. Always use a resin of low reactivity in casting such shapes, since a high-reactivity resin may melt the mould surface when curing.

Moulds of glass, PVA, formica, melamine sheet

The procedure is the same as for wood and board. These moulds require no sealing; but glass should always be waxed thoroughly before the PVA release agent is applied.

Making the mould

Finally three general rules for making piece moulds:

Always plan the most efficient moulding order for each piece.

Always ensure that mould divisions are placed at such an angle that the pieces can be removed easily from the positive and the cast, i.e. make sure that 'locking' does not occur.

Always plan the mould divisions so that the resultant seams in the cast are accessible.

Estimation of quantities

Correct estimation of the quantities of materials is an important factor in using polyester resin and glass-fibre. It divides into two operations. The first is to estimate materials for the total job in hand, i.e. the amount of gel-coat resin, laminating resin and glass-fibre mat. The second operation is to estimate suitable working quantities, i.e. the amount of either gel-coat resin or laminating resin which can be catalyzed and used before gelation, etc. The first estimation can be made more accurately than the second, which depends on more factors, such as the skill and experience of the user, the temperature and so on.

Estimating total quantities

A number of ways are open, according to the nature of the job to be undertaken. In deciding the number of laminates, factors to consider are the thickness, strength and rigidity required. The scale provided will be of some assistance in assessing this; but because many of the shapes and structures to be cast/made are irregular, values given are only approximate. The prospective resin user is advised to look at various articles manufactured from glass-fibre/resin to familiarize himself with average thicknesses and other qualities. When the number of laminates has been decided on, it is easier to estimate the resin quantities. Since even with irregular shapes it is easy to assess the amount of mat to be used (see 'Cutting mat to size'), this factor provides a suitable base from which to calculate the resin quantities. As a general rule, the weight of resin required is twice the weight of mat required. Estimation simply entails cutting the mat to size, weighing it and doubling the weight to arrive at the weight of resin required. The quantity of gel-coat required can be estimated in similar manner although this varies according to the

Estimation of quantities

viscosity of the gel-coat; but generally the weight of gel required should be the same as the weight of one layer of $1\frac{1}{2}$ oz mat (i.e. $1\frac{1}{2} \times$ weight of one layer of 1 oz mat). Where the shapes to be cast/made are regular, the table may be used with confidence. In estimating gel-coats remember that fillers increase the weight more than the bulk – and allow for this.

Nomograph for determining the weight of additive required: place a straight edge from the 'Weight of resin' scale to the '% of additive' scale. The intersection of the straight edge and the 'Weight of additive' scale shows the weight in grams of the additive required. It may be assumed that the weight of catalyst or accelerator in grams is equivalent to its volume in cc.
Examples:
Weight of resin is 5 lb. and 4% additive is required;
The amount of additive necessary is 91 g.
Weight of resin is 10 lb. and 1% additive is required;
The amount of additive necessary is 45 g.

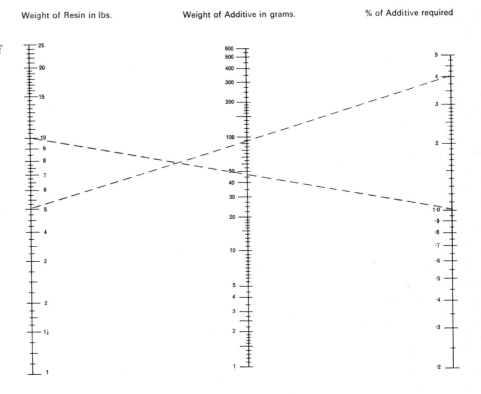

Weight of Resin in lbs. Weight of Additive in grams. % of Additive required

Estimating working quantities

There are general rules about estimating working quantities (for casting by hand lay-up processes) which are applicable in all cases. As it is preferable to apply the gel-coat in such a way that the entire mould surface is covered with one mix, it is advisable to calculate as nearly as possible the pot life – time between catalyzation and gelation – required and adjust this by the amounts of accelerator and catalyst used, rather than to accept a pot life of, say, ten minutes and mix as much gel as can be applied in that time. Use of the tables is helpful in doing this; but a test should be made before embarking on the final job. Similarly, it is best if the resin for one complete laminate can be catalyzed and used at one time. Where this is not possible because of the size or complexity of the mould to be filled, preparations to enable rapid catalyzation and application of subsequent mixes should be made, e.g. the total resin required for one laminate or gel should be decanted into several mixing containers in equal amounts, so that, as one container is used, the next can be quickly catalyzed and applied. This permits the laminate to cure at approximately the same rate and minimizes distortion due to uneven curing. It is difficult for the average caster to apply more than 5 lb of resin, either gel or laminating, in one mix to all but the simplest moulds without the exothermic reaction of such a bulk causing premature gelation in the container. Correct estimation of additives, fillers, etc. to resins can be obtained by consulting relevant percentage charts provided. Correct estimation of the percentages of catalyst or accelerator to give specific pot life is simplified by use of a nomograph provided, although only a test mix will indicate which percentage mix is most suitable.

Gel-coats: materials and mixing

The gel-coat is the first layer of resin in a hand lay-up laminate. The word is also used to describe the general type of resin used for this initial coat, and for this meaning we shall use here the term gel-coat resin. It is allowed to gel and does not contain glass-fibre reinforcing. Its main function is to prevent the subsequent layers of glass-fibre reinforcing from being exposed on the mould surface of the laminate. Gel-coat resin may contain pigment or metal filler powders to obviate the need for painting the finished cast. As it has no other reinforcing during its application and gelation, it must be thixotropic (fluid during application but jelly-like and self-supporting when applied). This quality enables it to be applied in an even layer without sags or runs. For the resin to provide a satisfactory cast surface it must be thick or firm enough to withstand the tension created by shrinkage in the first lamination, which can contract the gel-coat so that it follows the contours of the glass-fibre mat, giving an uneven finish. It must also have properties which prevent the formation of bubbles or pin-holes – making more finishing work necessary – on the surface of the gel-coat. Thus gel-coat resin requires a number of properties not necessary in an ordinary laminating resin. Also the nature of the job may place a particular emphasis on one or more of these properties. For example, a mould with steeply inclined surfaces will require a more thixotropic gel-coat resin than a shallow mould will require.

There are a number of proprietary general-purpose gel-coat resins which may be used, following the makers' instructions for casts which require no special properties of a gel-coat other than the general ones described. However, as the nature of sculptural casting, etc. usually varies, even

within one particular job, it is recommended that gel-coat resins be specially mixed for the job in hand.

Here is a descriptive list of materials used to make up a variety of gel-coat resins, followed by a list of formulae for typical mixes and a general note on mixing and application:

Thixotropic resin or paste

A highly viscous resin with thixotropic properties, this can be mixed in varying proportions with ordinary laminating resin, to give the kind of gel-coat needed. Moulds with steeply inclined surfaces require an extremely thixotropic gel-coat resin. Most proprietary thixotropic resins are too viscous to be used without the addition of laminating resin. Thixotropic resin in the gel-coat mix will prevent rapid 'settling' of an inert filler such as metal powder. This is not always desirable.
Neat thixotropic paste or resin, plus accelerator and catalyst can be used as an adhesive for joining small casts. It can also be used as a surface filler, but this practice is not recommended.

Flexible resin

This type of resin is generally used with a rigid laminating resin and is useful as a gel-coat resin additive. It improves the impact strength and shock-resisting properties of the gel-coat. It has a low exotherm, which reduces the chances of cracking or warping due to an excess build-up of heat. For this reason a gel-coat with added flexible resin is highly suitable when casting from a heavily textured plastic waste mould or vina-mould; it makes the final cast less likely to crack because of

chipping out and it minimizes the chances of excess heat build-up and cracking where large amounts of resin gather in recesses and collect in the textured surface. It can also be incorporated into a laminating resin mix where a cast with high impact strength is required, and used in solid casting processes involving polyester resin.

Powder fillers

These come in several kinds of powdered substances which enhance the properties of resin for casting. Most are inert and take no part in the chemical reaction, though they may delay or speed up gelation time a little. A suitable filler (with laminating resin) can often obviate the need to use more expensive types of resin. Fillers can be used to increase the thixotropic properties of a resin, to prevent the formation of pin-holes on the surface of a cast, to give a metallic appearance (with metallic fillers) to the finished cast, to reduce shrinkage and increase rigidity, compression, strength and weight of a cast, and to increase slightly the bulk of resin (extenders), though the argument that this cuts the cost – because filler is cheaper than resin – is fallacious.

General filler powders

The most common general filler is made of precipitated chalk, and others of slate powder, china clay, whitening, and talc. Their functions are to decrease shrinkage and increase compression, strength and weight.

Mixed in a gel-coat resin, they prevent pin-holes in the surface of the cast. They are normally added in the proportion of 25–50% by weight. They retard the gelation time and extra acceleration is usually required.

Gel-coats: materials and mixing

Mixing is made easier if the resin is added slowly to the filler, the mix being stirred all the while. All tend to whiten the gel a little and this has to be taken into account when the gel is to be coloured. Extra pigment may have to be added to compensate for this. These fillers add little thixotropic quality to the resin.

Thixotropic fillers

These are aerosil, sawdust, and polyester resin dust. Aerosil, a silica product and an extremely light powder, increases the thixotropic properties of gel-coat or laminating resin. It is difficult to mix without a mechanical mixer, and the mixing procedure is the same as for general fillers. Aerosil can also be purchased in paste form. Sawdust and polyester resin dust must be thoroughly dry and the resin dust thoroughly cured. These have a somewhat limited application and they are best used in the consistency of putty for plugging holes and so on when a commercial paste stopper is not available. They are not recommended for use in gel-coats.

Metallic filler powders

Finely ground filings of bronze, aluminium, copper, brass and other metals have properties similar to those of the general fillers listed. They are used to give a metallic appearance. As the quality of the metallic finish depends on the amount of metal powder near the surface of the cast, it is best not to use them with a high concentration of thixotropic resin, as this will prevent the subsidence of the filler to the mould surface. This factor means that special consideration should be given to mould making where metallic powders are to be used in the final cast (see Making the mould, page 32.).

Gel-coats: materials and mixing

Fibrous fillers

Chopped glass-fibres, mixed with a gel-coat, are invaluable for use in a mould so heavily textured that mating without getting gaps between laminate and gel is impossible. Chopped or shredded glass-fibres used in a gel-coat resin containing flexible resin can be used to 'fill' the texture and provide a smooth surface for subsequent laminations. Chopped glass-fibres can be made by chopping a number of lengths of glass-fibre roving or by shredding and chopping chopped strand mat.

Pigments

It is often wished to incorporate colour in polyester resin so that a cast requires no subsequent painting. Special pigments dispersed in a minimum amount of polyester resin can be obtained for this purpose. Quantities of up to 5 % by weight may be added to the resin without affecting the curing, although where over 2 % is used extra accelerator must be added to the mix. Pigment should be added to a gel-coat *after* all the other ingredients have been mixed, as fillers and other materials can affect the density of colour obtained. To obtain a cast with maximum opacity and density of colour, pigment should also be added to laminating resin.

**Formulae for
typical gel-coat mixes**

General purpose, clear gel-coat – no fillers:
good base for colour mix where filler might reduce colour brilliance or
where translucent colour is required.

Rigid laminating resin	50 parts by weight
Flexible resin	10
Thixotropic	40
Accelerator	4
Catalyst	3–4

Pigment, when required, up to 5 % total mix.

General purpose gel-coat – with fillers:
used where dense, pinhole-free surface is required and factors such as
colour are of secondary importance.

Rigid laminating resin	40 parts by weight
Flexible resin	10
Thixotropic resin	20
Filler (precipitated chalk, slate powder, etc.)	30
Accelerator	4
Catalyst	3–4

Gel using aerosil filler:

Rigid laminating resin	90 parts by weight
Flexible resin	10
Aerosil	5
Accelerator	4
Catalyst	3–4

Gel using metallic fillers:

Rigid laminating	60 parts by weight	Metallic powders vary in weight but can be added over thirty parts in weight with adjustment of accelerator. Test first for surface quality and gelation.
Flexible	10	
Thixotropic	10	
Metallic filler powder	30 +.	
Catalyst	3–4	
Accelerator	3–4	

These formulae may be adapted reasonably freely and are intended only as a guide. However, in using a gel mix not specified here, a test should always be made before a final cast is undertaken.

Mixing gel-coat resin mixes

To save time and prevent wastage of materials, estimate the amount of gel-coat mix required for total job. All gel-coat should be mixed at the same time, to ensure uniformity in the final cast surface. Polythene buckets are the most suitable containers and should be deep enough to allow vigorous mixing without excessive spillage. Mechanical mixing is the most thorough and effective (see Basic equipment and tools, page 27). Where mixing is done by hand a clean piece of wood is the best stirrer.

Here is a mixing programme, using two containers:

1. Estimate quantities.
2. Mix resins to be used. Always add the lighter resins to the more viscous ones, i.e Thixo + Flexible + Laminate.
3. Add *accelerator* to resins and mix thoroughly.
4. Place bulk of filler (if any) to be used in a dry container and stir in ready-mixed resins.
5. Add pigments (if any).
6. Adjust mix, if necessary, either by adding more filler or thixotropic resins. This should be done by mixing a little of the total mix with the extra filler/thixotropic paste and adding the remainder of the total mix to it.

The whole mix should then be allowed to stand for at least thirty minutes to allow air bubbles caused by mixing to rise to the surface. Immediately before use the whole mix should be gently stirred with a clean stick.

Application of gel-coat

This is an extremely important operation and should not be rushed. The release agent must be thoroughly dry on the mould/casting surface. A test mix of resin should be made to ascertain gel/time, etc. Enough gel for the surface to be covered should be decanted into a clean, dry, polythene basin and catalyzed to give it a pot life long enough to allow unhurried application. The gel-coat resin is best applied with a soft brush, of a size suitable for the size of the job in hand. For large flat areas with no texture, gel-coat resin can be applied with a mohair roller. In view of cleaning difficulties, however, brushes are generally more convenient for any but the largest jobs. The resin should be brushed gently and evenly on to the mould surface, and first the top, higher parts of the mould so that any tendency to run can be evened out as application progresses. Do not 'scrub' the gel in as this may disturb the release agent. *Remember* the resin will gel more quickly in the pot, so, if the mould surface is large, it is advisable initially to distribute the resin over a number of small areas, then brush out evenly over the remainder of the mould. If there is a tendency for the gel to gather in puddles *either* turn the mould so that this is avoided, *or* turn the mould so that excess gel is run out *or* keep dispersing the puddles gently with the brush until initial gelation has taken.

If for any reason puddles of resin have accumulated, and there is no easy way to disperse or get rid of them, make sure that curing is not so rapid as to cause cracking by laying a damp sponge over the affected parts as soon as gelation has taken place; this will lower the temperature and effect an even cure. (Remember to dry any resulting moisture off the gel-coat before starting to laminate.)

Hand lay up for a vina-mould negative.

1. Vina-mould exterior showing plaster case and wooden support.

2. Application of gel-coat.

3, 4. Application of laminate.

5. Completed laminate.

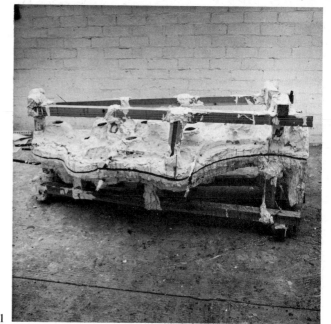

1

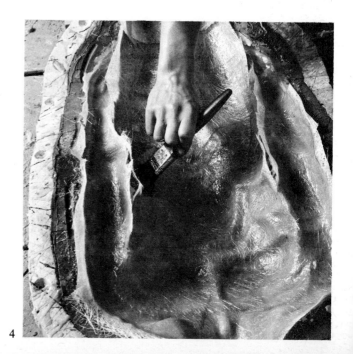

4

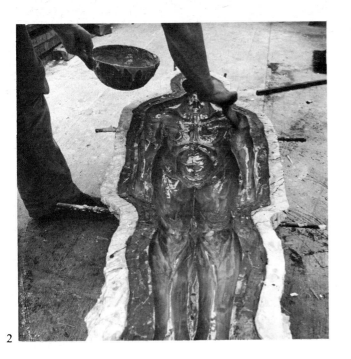

2

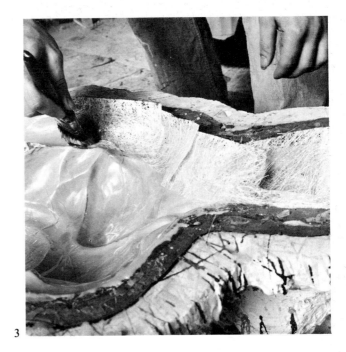

3

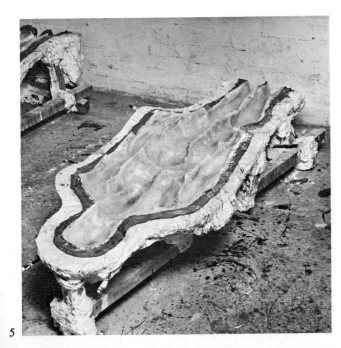

5

1, 2. Removing vina-mould from
completed laminate. Note the
exterior plaster case has been
removed previously.

3. Taping the trimmed pieces of cast
together.

4. Pouring resin down seams to effect
a join.

5. The completed cast.

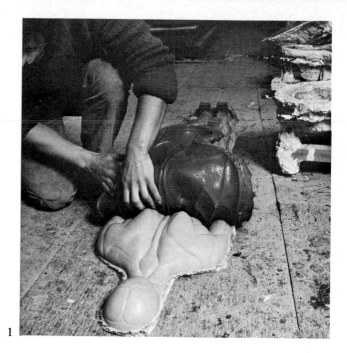

1

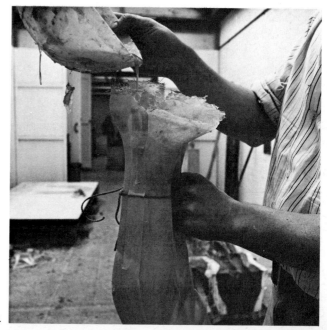

4

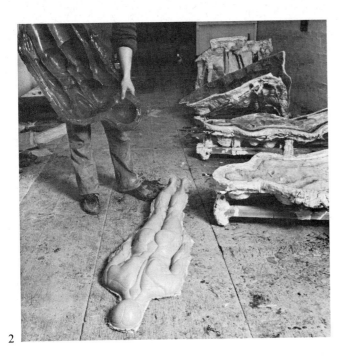

2

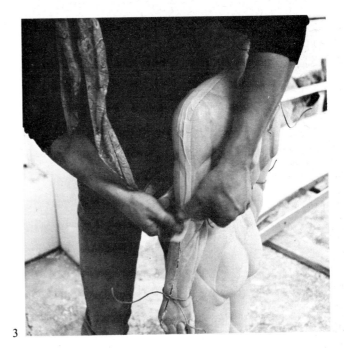

3

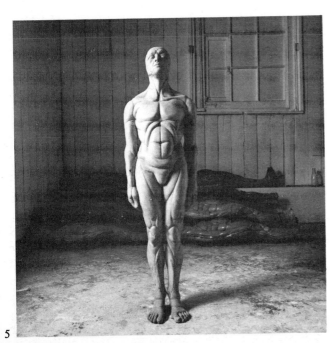

5

69

Laminating resins

Of the proprietary brands of laminating resins, the ones normally suitable for hand lay-up work are those of low or medium reactivity; the exotherm is not high and there is less risk of cast warping due to uneven or rapid heating. See manufacturers' specifications for the special properties of various resins, as these are sometimes critical. A general-purpose rigid laminating resin (cf. flexible resin) will be of medium viscosity and low or medium reactivity. Such a resin will also be suitable for blending with other resins and fillers in the mixing of a gel-coat resin. As a medium viscosity resin, it will have slight thixotropic properties that will prevent drainage from mat on an inclined surface; but where vertical surfaces are to be cast it will be necessary either to add thixotropic resin to it or to use a resin of higher viscosity. As filler powders are easier to mix when the viscosity of the resin is low, a low-viscosity resin is a useful base for laminates that are to be applied to shallow moulds with no steeply inclined surfaces, where a thicker, more rigid cast is required, necessitating the use of a filler. Some laminating resins are sold with accelerator added. It is useful to know what proportion of accelerator has been added; but *whether this has been specified or not*, it is always advisable to make a test mix. Like gel-coat resins, laminating resins can be mixed with other additives, fillers or flexible thixotropic resins, but *remember* that ease of laminating depends on the fact that the resin is always of the minimum viscosity and that, where for some reason the use of a high viscosity resin is unavoidable, a longer pot life should be aimed for. When using additives with a laminating resin, i.e. pigment or fillers, the same rules as those for mixing gel-coat resins apply. *Always* add resin to filler powder, etc. (see page 57). When catalyzing an unaccelerated laminating resin, *always* add the

accelerator first and mix thoroughly before adding the catalyst. This has a two-fold purpose. As the accelerator is a pinky-mauve colour, a thorough mix can be seen to have been achieved by observing the resin change from a clear liquid to a pink liquid. Addition of catalyst changes this mix to a darker shade of red-brown and thorough mixing can be checked by a similar observance of uniform colour change. This is extremely important and deviation from this mixing order may result in unmixed catalyst coming into contact with neat accelerator.

It is best to mix laminating resin in a polythene bucket or round polythene container with fairly high walls. Such containers are not, however, the easiest to work from. The best compromise is to use a bowl, not basin (see illustration), as this shape facilitates thorough mixing and is reasonably convenient to work from and to clean after use. When laminating into an unfamiliar mould, etc., always try a test mix to test for drainage from inclined surfaces and rigidity and *always* try to estimate pot life correctly, erring on the side of a slow mix.

Glass-fibre mat

For most laminating by the hand lay-up process, chopped strand mat is the most suitable type of glass-fibre. Extremely adaptable, it will fulfil a wide variety of reinforcing functions. It consists of 2 in. long filaments of glass bonded with a resin-soluble medium into a mat. There are three principal weights per square foot – 1 oz, 1½ oz, and 2 oz. The choice of weight is not extremely critical so far as structural strength is concerned, since 3 oz can be improvised from 3×1 oz and so on. However, the laminating process itself is made much easier if the right weight mat is selected. As the most economical way of purchasing mat is by the roll, obviously a general choice of mat weight should be made, depending on the type of casting likely to be undertaken. Choice will be influenced by (1) the size or shape of moulds/casting surfaces to be used and (2) the kinds of laminating resins generally used.

Size or shape

This is perhaps the most important factor. Heavy mat (3 oz) is extremely difficult to laminate on an uneven surface and almost impossible to work into or round a corner, as it has a tendency to spring out of place. Its use is *strictly limited* to very simple and generally large and untextured moulds. A medium-grade (1½ oz) mat may be hard to handle with very small moulds possessing intricate detail, but is quite easy to use on most other types of moulds. The 1 oz mat should be used only for small, awkwardly detailed moulds, as its resin-holding capacity is small. The use of many layers of 1 oz mat to build up a thickness is not desirable. *Remember* that heavy mat can be separated, that is, peeled into thinner layers for laminating awkward spots. This practice, like its reverse (using thin mat in many layers) should be reserved for emergencies, as it

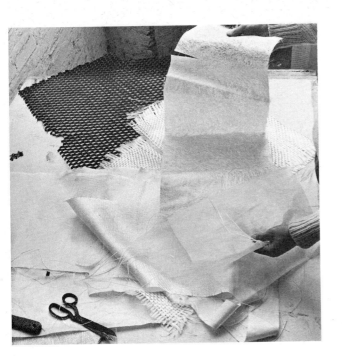 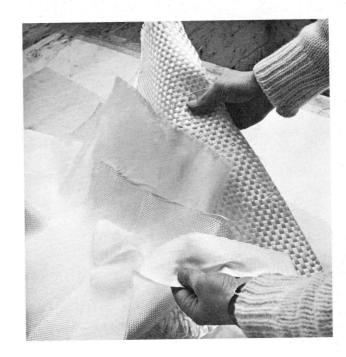

Examples of glass-fibre matting.

is difficult to gauge such factors as correct thicknesses when the standard forms of chopped strand mat are disturbed.

Types of resins

Because 3 oz mat is the most difficult to impregnate, it should not be used in conjunction with a laminating resin of marked thixotropic properties, which makes the work harder and increases the likelihood of getting bare patches in the laminate. The reverse is true of the lightest mat – where to compensate for its lack of 'body' a laminating resin with thixotropic properties may be used.

In general, a heavier mat gives a more rigid and stronger cast more quickly than a light mat, but *only* if mould/resin conditions are correct, i.e. if they allow for *easy* laminating.

Release agents

A release agent is a substance used to prevent the adhesion of polyester resin to the mould/casting surface. A number of release agents are available, some with general and others with more specific applications. The kind to use depends on the type of mould and cast finish required. Remember, however, that whatever the release agent used, its effectiveness depends largely on correct application. A fine mould finish may be wasted, if an unevenly applied release agent results in an unevenly surfaced cast. The available types of release agent, their most suitable uses, and the methods for applying them are:

Waxes

Most hard-wax polishes are suitable for use as release agents. Domestic wax polishes can also be used but must first be tested as they sometimes contain ingredients that affect the resin in some way. A hard-wax polish is only to be used on a previously sealed surface and is best followed by a PVA liquid release agent. In this combination the main release is effected by the wax and the PVA prevents the wax from adhering to the cast surface. All porous moulds – plaster, wood, hardboard, cardboard and so on – should be sealed and then polished with wax. Apply the wax generously, then polish off to a high shine. On heavily textured moulds, where polishing is difficult, a wax emulsion should be used. To remove any traces of wax from the finished cast a strong detergent should be used. Silicone waxes are best avoided where the finished cast is to be painted. Silicone polishes are very hard to remove and paint will not key to a surface that has any traces of silicone on it. If no other polish is available, ensure an even coat of PVA release agent and, if cellulose paints are to be used, add a silicone additive (see Finishing methods: painting, page 106).

Release agents

Wax emulsions

These are ideal for plaster waste moulds (provided the plaster is dry, wax emulsion can be applied without prior sealing), hardboard moulds and wood. They are also suitable for non-porous surfaces. The emulsion should be smeared on lightly but thoroughly with a slightly damp cloth and left to dry completely. Light polishing will help to remove any unevenness of surface. Wax emulsion adhering to the final cast can be removed with a strong detergent. Wax emulsion is also particularly suitable for heavily textured moulds where an initial hard-wax polish is difficult to apply. In these cases it should be applied sparingly with a soft brush.

Polyvinyl alcohol (P V A)

Perhaps the most useful release agent suitable for any type of mould, P V A is water-soluble and is easily applied with a soft cloth, sponge, brush or spray-gun. Some PVAs come in a slightly reduced form and require thinning with either water or – where quick drying is essential – a little methylated spirits. Moulds to be separated with P V A must be sealed properly and wax polishing before the P V A is applied facilitates the removal of the cast from the mould. Thin P V A solution is sometimes repelled by a high wax polish. Dusting the mould lightly with french chalk will prevent this and allow a smooth and even application. P V A sticking to the cast can be removed by washing with warm water. A light coat of P V A on a mould of vina-mould ensures a tack-free cast surface. Where a number of casts are to be taken from the same mould, a fresh application of P V A may be unnecessary. Usually there will be P V A adhering to the mould surface, and this can be respread with a damp sponge. As P V A is extremely water-soluble, care should be taken to avoid

touching a mould surface treated with it, since even a slight amount of perspiration on the fingers can remove the coating of P V A.

Other release agents

A number of plastics and waxes in sheet form can be used as release agents on flat or one-directional surfaces. Here cellulose acetate sheet (or cellophane) or P V A sheet can be used, although thin sheets (002–003in.) are inclined to wrinkle as the resin shrinks and are not suitable where a smooth flat surface is required.

Celluloid is *not* a release agent. Cellulose acetate also comes as a liquid and is best sprayed on to a well-finished simple mould (cellulose primers). Cellotape and similar tapes are generally made from cellulose acetate and can be used for covering holes and edges, and similar purposes in moulds. Wax sheeting and plasticine are also separators and can be used for simplifying moulds and providing spaces for additional fixing.

Shrinkage problems

Unfilled or unreinforced cast polyester resin will shrink up to 7–8 % volumetrically. The introduction of glass-fibre reinforcing normally reduces this shrinkage somewhat; filler powders can reduce the shrinkage further to about 1%. Shrinkage becomes a fairly severe problem in casting simple geometric shapes. For example, with a cube or any polyhedral solid, incorporating plane surfaces set at definite angles to one another, shrinkage will generally pull the laminate in about 1–2° in a laminate cast from a mould with 90° corners. On a cube structure this becomes extremely apparent and results in a box with slightly concave sides. On more 'organic' shapes shrinkage is less visible, although it will always be noticed when joining two dissimilar pieces with common edges. This is generally no problem (see Joining methods, page 93). With more clearly defined geometric shapes shrinkage may be dealt with in a number of ways. As it is almost impossible to calculate the exact amount of percentage of filler, amount of styrene in resin and so on – the user will have to take maximum precautions if visible shrinkage is to be avoided.

The following are the precautions that must be taken to obtain an apparently undistorted cast:

Always ensure that correct laminating procedure is maintained. Above all, treat all casting areas consistently. Shrinkage becomes most apparent when it is uneven.

Always use maximum amounts of fillers (mineral). This does not mean

Causes and results of shrinkage due to excess of polyester resin.

1. Shrinkage of excess resin in corner will cause distortion of angles.

2, 3. Shrinkage of excess resin causing indentations on surface of cast.

1

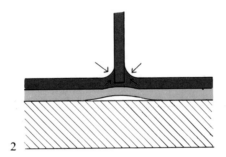

2

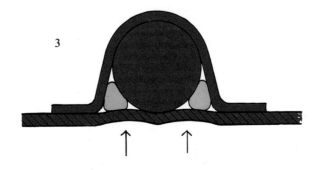

3

that the resin should be overloaded with filler; ease of lay-up must be maintained.

Where flat surfaces are required, always balance the laminate, i.e. the last layer of the laminate should consist of a gel-coat brushed on to the same thickness as the one on the cast surface.

Always maintain an even thickness of laminate. Compensation in the form of altering thickness can control shrinkage, but this practice needs a degree of control achieved only through long experience.

Always take care to introduce additional reinforcing and fixtures well after the final cast is cured (see Reinforcing methods, page 82). Avoid hurried mixing and catalyzing of resin used for these purposes. An over-catalyzed resin will heat rapidly, and soften the cured cast locally, so that it will not resist the shrinkage of the applied pieces. This causes surface indentations.

Where flat-planed shapes are to be constructed, shrinkage can be minimized by constructing them from cut sheets of cast polyester/glass-fibre laminates. An epoxy resin should then be used to join the pieces or they may be fixed mechanically to a rigid frame of metal or wood. On flat shapes, the use of a sandwich construction, i.e. polyester laminate foam polyurethane/polyester laminate, avoids distortion through shrinkage. Alternative ways are described in the next section.

Shrinkage problems

Use of a balancing gel-coat to counteract the effects of shrinkage on flat surfaces.

balancing gel-coat
laminate
gel-coat

Filler must be added gradually in thin layers to correct this type of defect (concave sides).

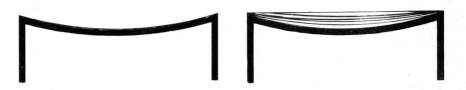

Reinforcing methods

Small glass-fibre, polyester resin casts normally require no reinforcing, but larger casts or fabricated structures sometimes do. Reinforcing must be done when either the shape of the cast itself is not structurally strong or a part of the cast has to fulfil some other mechanical function. Reinforcing is also sometimes necessary to prevent distortion of flat surfaces. There are often several possible solutions to the problem and they should be considered as early in the casting or fabricating process as possible. The principal methods are (1) to include rigid materials in the cast during or after laminating and (2) to form the laminate in such a way that it has a rigidity and strength of its own. Their application, according to types of castings, is as follows:

Medium and large casts of irregular shape

To stiffen areas of the cast where flexing might occur, ribs are formed in the laminate by laying lengths of D section paper rope (at, say, 6in. intervals) on the area to be reinforced. After the laminate is complete, but before a complete cure has been affected, the paper rope is covered with one or two glass-resin laminates (see diagram). This has the effect of making glass-fibre-resin tubes of high structural strength. Dry 1×1in. wood or rolled-up newspaper can be used in the same way if paper rope is not available. A number of sizes of paper rope are manufactured for this purpose. The rope has a soft wire core and can be pre-bent to follow the contours of the mould surface. The edges of an open cast can be reinforced in the same way. For reinforcing shapes of a more regular nature this method has several disadvantages, as the shoulder of resin that may accumulate on either side of the rope can cause local shrinkage which will show on the surface of the cast as an indentation.

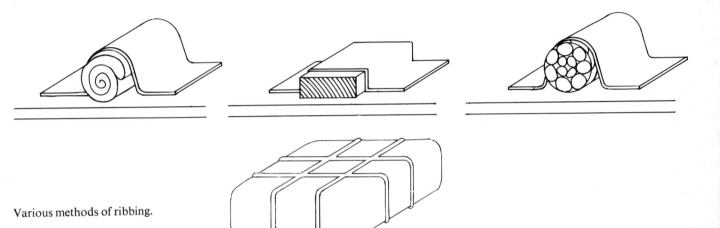

Various methods of ribbing.

Medium and large regularly shaped casts

Because of the shrinkage risk, it is often better, when reinforcing regularly shaped casts, to wait until the complete laminate has cured. Then wood or metal may be used to make a substructure of ribs or struts. To prevent shrinkage and distortion these are best fixed in place using a laminate of low-reactivity epoxy resin and glass-fibre or a polyester/glass laminate that has been catalyzed to give a slow gel time. This ensures that the exotherm produced does not soften the cast locally and produce distortion.

Medium-size irregularly shaped casts

Where an extremely rigid cast is desired it may be possible to use polyurethane foam as a reinforcing agent. The cast is assembled and formed (see Joining methods, page 93). An aperture of 4in. or 5in. must be provided. If this does not naturally occur in the cast, one should be cut (retain the piece cut out). Then pour liquid polyurethane foam into the cast, and allow it to expand and cure. When cured, trim off the overflow from the cast and reseal the aperture with the original piece removed. This method requires considerable speed of execution, since, once the two components making up the liquid polyurethane foam have been mixed, the user has some thirty seconds in which to pour the mixture into the cast before expansion takes place. The manufacturers of liquid polyurethane foam provide extensive data on its use, and should be consulted before this method is undertaken.

Casts or fabrications with large flat areas

This method of reinforcing is employed when large flat areas require stiffening, either to increase their structural strength or to prevent distortion through sagging or shrinkage. It may also be used to make flat sheets with two good surfaces varying in thicknesses from $\frac{1}{4}$in. to 6in. A balanced sandwich construction is built up, consisting of one gel-coat, one or two laminates of glass-fibre-resin, flat sheets of rigid polyurethane foam or Dufaylite honeycomb reinforcing, one or two laminates of glass-fibre-resin and balancing gel-coat. This method requires quite substantial preparation and is mainly used to produce flat sheets which are then fabricated into other constructions. However, with foresight and not a little improvisation, it can be used to reinforce casts being made from moulds. The materials required are enough glass-fibre and resin to

laminate double the area of the required flat sheet, either one or two laminates per side, and enough rigid polyurethane foam or Dufaylite honeycomb reinforcing of the desired thickness to cover the area of required sheet (in special cases an epoxy resin adhesive). The equipment needed is: casting surface, piece of blockboard or chipboard of the same area as the required sheet, weights to improvise a press (e.g. sandbags, bricks, building blocks) and rollers to ensure even laminatings.

Polyurethane foam method

For polyurethane foam reinforcing, follow this procedure:
1. Prepare surface for casting, using suitable release agent, etc.
2. Lay down gel.
3. Mix enough laminating resin to laminate one or two layers of mat (depending on strength required) and to apply a coat to the polyurethane sheet.
4. Lay down laminates.
5. Brush on coat of resin to polyurethane.
6. Place polyurethane sheet on top of laminates.
7. Place sheet of chipboard or blockboard on top and weight down.
8. Allow time to achieve a hard cure, remove from casting surface and repeat for other side.

As polyurethane sheeting is an extremely efficient insulator the heat build-up during this process can be excessive. Make a small test mix and adjust the amount of catalyst and accelerator to be used accordingly. In most cases it will be necessary to reduce the amount.

1, 2, 3. Paper rope or rolled newspaper
and its applications for reinforcing.

4. Dufaylite honeycomb.

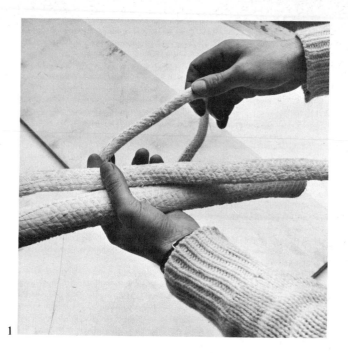

1

4

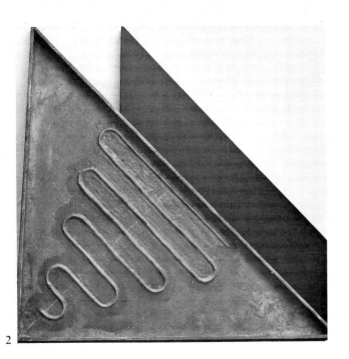

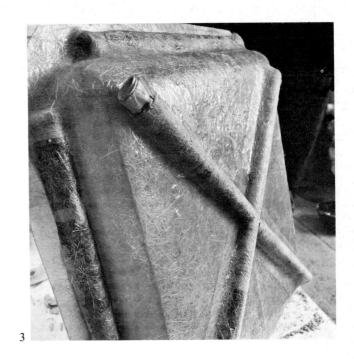

2

3

Dufaylite honeycomb method

For reinforcing with Dufaylite honeycomb:
1. Prepare surface for casting as above.
2. Lay down gel and allow to achieve firm cure.
3. Lay down one laminate of glass-resin and allow to achieve firm cure.
4. Lay down second laminate and position Dufaylite honeycomb on top immediately, i.e. before gelation.
5. Continue process as for polyurethane reinforcing.

The first laminate must be allowed to cure hard to avoid surface indentations on the shape of the honeycomb cells. The indentations appear because of the greater bulk of resin which is formed where the walls of the individual cells penetrate the laminate (see diagram). Where a very tight sheet is to be formed and only one laminate is required, this problem is overcome by allowing the laminate to achieve a firm cure and then adhering the honeycomb by means of a liquid epoxy adhesive. This is most conveniently applied to both laminate and Dufaylite with a mohair roller.

For reinforcing flat areas in casts to be taken from moulds, the

Method of reinforcing flat shape using paper honeycomb or polyurethane.

procedure is essentially the same. The main difference is that, because the cast is contained in a mould, it is impossible to reverse the process to provide the balancing laminate. This is overcome by cutting a sheet of cheap hardboard to the size of the flat area, treating it with release agent, etc., laying up the balancing laminates and then placing the sheet on top of either the polyurethane or the Dufaylite already situated and bonded on to the laminates in the mould. When cure is complete, the hardboard is removed and the cast can be removed from the mould. Alternatively, the Dufaylite or polyurethane can be incorporated with the backing laminate before casting and then used as above. This obviates the use of hardboard or similar material. However, care should be taken to see that the pre-laminated backings cure and do not become warped before their incorporation in the cast.

Prefabricated chipboard or plywood structures may be clad with a glass-fibre resin laminate using the same procedure as for polyurethane foam.

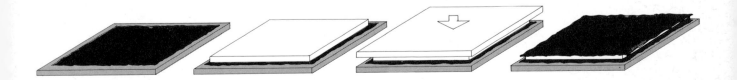

1

2

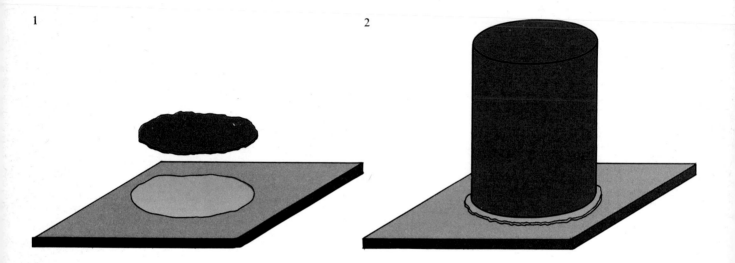

Sequence showing completion of geometric
forms using a casting surface. The same method
may be used to apply reinforcing lips to open
shapes.

1. Gel-coat and laminate is laid down on the
casting surface.

2. The open-ended geometric form placed on
the wet laminate.

3. Weight is applied to embed edge securely
in the laminate, as shown in diagram 4.
Excess laminate is then trimmed from the
edge as in diagram 5.

Reinforcing methods

3

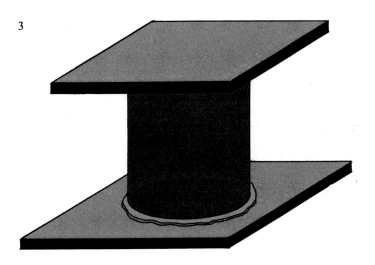

4

5

Reinforcing methods

Methods of reinforcing edges.

1. Clay is pressed round edge of cast.

2. A triangular fillet is removed.

3. Gel-coat resin poured into indentation.

4. After curing, clay is removed.

5. Using wood and aluminium reinforcing.

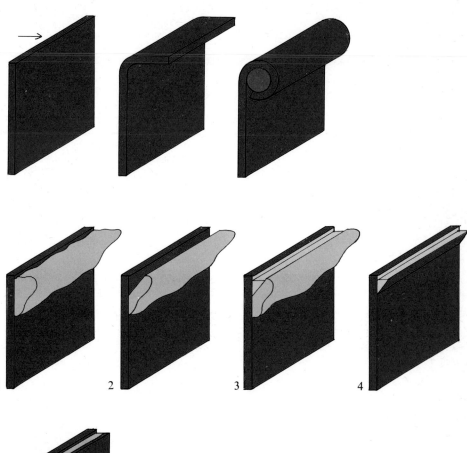

Joining methods

The effectiveness of polyester resin/glass-fibre for casting or making sculpture often depends on the quality of the joins used in fabrication. In most systems of fabrication the method used to join one element to another is critical: when glass-fibre/polyester resin are the main materials, it is of paramount importance. There are a number of joining methods. The correct one for a particular job will have the optimum strength and appearance but may not always be the most easily executed.

The nature of the job or joins in hand should be categorized after a consideration of the following interdependent factors:

1. Materials to be joined.
2. Size and shape of pieces to be joined, i.e. small regular, small irregular, large regular, etc.
3. Strength of join required, i.e. to support additional weight, etc.
4. Access to inside of cast or reverse side of join (in a small completely enclosed cast inside access for laminating a seam will be impossible).
5. Ease with which pieces to be joined may be held in place while joining (large pieces of a cast may be difficult to support while laminating a seam).
6. Final appearance of join, for instance whether it is to be completely concealed. Access to the outside of a join for finishing may be impossible in some cases, if the cast is assembled in a particular sequence. This may rule out some methods of joining.

When this has been done, select one of the following three methods – joining by a resin adhesive (epoxy or polyester), or a resin/glass-fibre laminate, or mechanical means such as bolts, screws and pop-rivets – and formulate a procedure for carrying it out.

Method 1: resin adhesive

This is simply a gluing process, only suitable for small casts requiring little structural strength or for joining large, flat surfaces to one another. The surfaces to be joined are trimmed, cleaned and roughened to provide a key for the adhesive. The pieces are either assembled and held in place while resin is applied to the seam or they may have the resin applied before they are assembled. This method is sometimes suitable for joining two halves of a small cast where inside access to the seam is impossible. In this case the five steps are:

1. Tape the two together with masking tape.
2. Drill a small hole in an accessible part of the cast.
3. Pour in catalyzed resin.
4. Tape the hole.
5. Swill the resin round the seam and allow it to cure.

If the cast is translucent, a pigment added to the joining resin will enable the user to see it through the cast and so make sure that the whole seam is covered. Pre-cut glass-fibre tabs may be used as additional reinforcing when this procedure is used (see page 98).

Below: methods of joining cured polyester/glass-fibre laminates using resin as an adhesive.

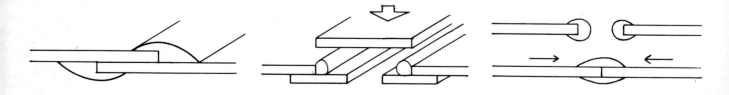

Method 2: resin glass-fibre laminate

This is the commonest and generally most suitable way of joining two sections of cured glass-fibre/polyester resin laminate where access inside of cast to the reverse side of the laminates is available.

1. The pieces to be joined are cleaned and prepared as in Method 1.
2. The pieces are assembled and held in place and the seam is sealed on the finished side with masking tape.
3. One or two resin/fibre-glass laminates are applied over the seam extending to a width of 1in. on each side of it.

Two halves of the cast are taped together. A small amount of resin is poured inside the cast and swilled around the seam.

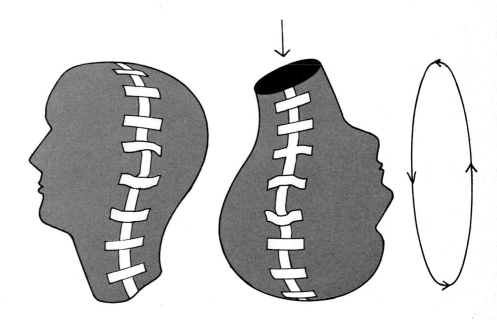

Joining methods

This method, with various modifications, is suitable for most casts and fabrications. Often in casts of a completely enclosed nature (say a large sphere cast in segments) it will be possible to join all but one piece by this method. There are two ways of completing the joining of such pieces. One is by simply using the procedure described in Method 1. The other is slightly more complex but generally more efficient.

Taking the example of a sphere pre-cast in four segments, the procedure is as follows:
1. Assemble three segments and apply laminates to seams.
2. When cured, tape in fourth segment.
3. Cut a circular hole approximately 6in. in diameter in the section opposite the taped-in segment.
4. Working through the hole, laminate fourth segment in place.
5. Replace circular disc in hole using Method 1.

This reduces the structural weakness that Method 1 induces, and with variations this practice can be employed quite successfully for joining enclosed casts, provided of course that they are large enough to allow of a 6in. diameter hole being cut in them. See diagram for additional ways of ensuring the strength of the joining of the replaced disc.

A sphere pre-cast in four segments.

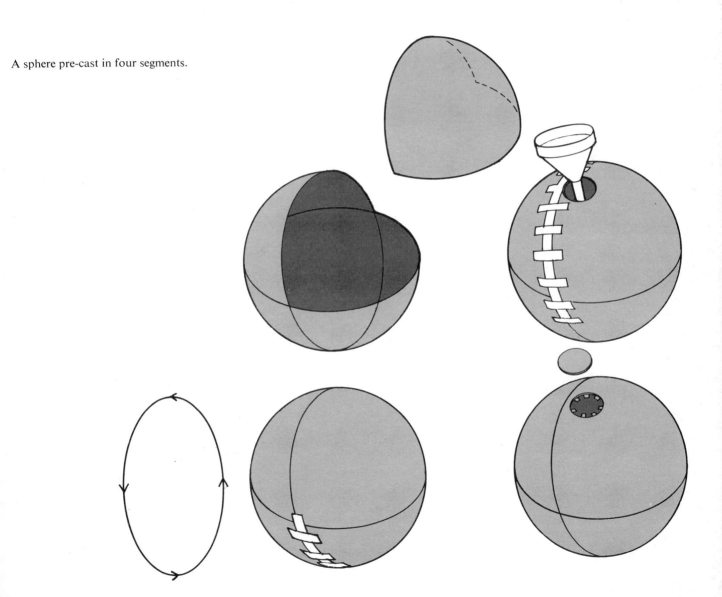

Joining methods

Ways of effecting limited access.

1. Using prelocated tabs of chopped strand mat to reinforce join. Small tabs of chopped glass mat are fixed with resin to one half of the cast and allowed to cure.
Gel-coat resin is then spread on the tabs and the edges to be joined. The halves are then brought together and taped in place.

2. Using an improvised brush to laminate a normally inaccessible seam from the inside.

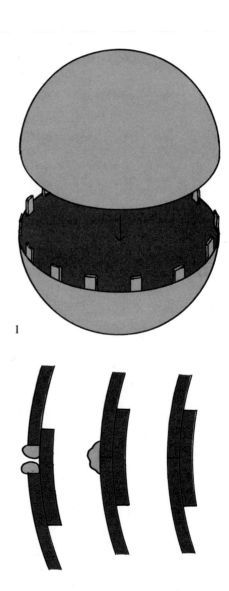

1

Joining methods

2

Method 3: mechanical means

Normally this is used to effect a join between a cured laminate and metal, wood, etc. or to make a construction capable of being taken apart. It may also be used in conjunction with Method 2 to provide additional structural strength in more conventional castings (see diagrams). The effectiveness of mechanical joins generally depends on the strength of the laminate at the edges of the join. Where metal fittings are to be attached to a glass-fibre/polyester resin laminate, they are best incorporated during lamination. If this is not possible, then the use of an epoxy adhesive plus glass-fibre reinforcing is recommended (see diagram).

Joining methods

Methods of joining two cured polyester/glass-fibre laminates.

Method of holding two surfaces to be joined in the same plane. After laminating. the wing nuts are removed and the bolts pushed through to the other side. If access to the inside is impossible the bolts may be trimmed flush with the surface.

Usual method of attaching a fixing to a cured laminate.

Finishing methods

These methods apply equally to finishing polyester/glass-fibre laminates, cast, fabricated or direct in the making of sculpture.

When all casting, joining and so on has been done, some reworking of the surface is usually necessary to 'finish' the piece. Seams have to be cleaned off, minor imperfections in the laminate surface have to be made good and often the piece will require painting. To a certain extent the amount of finishing required depends on how fastidiously the previous processes have been executed. Joins which have been made with care will need little filling. Laminates properly made will have few surface imperfections. But however much or however little finishing may be necessary, some basic procedures should always be followed. When the piece is finally assembled and all joins have been completed, but *before* any filling is done, *all* release agent must be removed from the surface. The best way is to wash with warm water and rub the surface with an abrasive detergent powder. The cast/job should then be washed with clean water and allowed to dry thoroughly, and is then ready for filling. Here are some typical finishing problems and their solutions:

Cleaning off excess resin

Much finishing work involves filling pin-holes, gaps in seams and similar faults. It is usually necessary to clean off an excess of the filler substance. Often excess resin that has seeped through a seam while pieces are being joined has to be cleaned off before filling can be done. General grinding and polishing methods obtain; abrasive or cutting tools should be used, starting with coarse, rapid abrasives and moving gradually to fine ones.

The best tool for removing excess resin quickly is a surform or similar self-cleaning rasp. These come in several shapes to suit the nature of the job in hand. After surforming, wet and dry abrasive papers are best used. Three grades – 100, 180, 250 – used in that order produce a surface suitable for painting. If a finer finish is required in, say, a self-coloured cast, finer grades of paper are used and the cast/laminate is finally polished with a cutting metal polish such as Brasso. Glass paper is suitable for rubbing down cured polyester laminate but the danger of inhaling resin dust must be borne in mind and a mask should always be worn. Similarly a drum sander can be used where large amounts of excess resin are to be cleaned off. (See Precautions, page 24.)

Filling gaps and indentations

Clean off all excess resin and apply Bondapaste, Tetrasyl or other filler resin with a wedge-shaped filling or stripping knife. If the seam lies on a curve, apply the filler with a polythene filler or a piece of hardened tempered spring steel. This will ensure that the surface of the filled area follows the same line as the remainder of the surface. Instructions on cans of filler resins invariably advise the user to leave an excess of the filler to be cleaned off. This is sometimes advisable; but where possible keep the excess to a minimum. Correct use of the proper filling tools allows this.

Small cavities

Small pin-holes, air bubbles in the surface of the laminate and similar cavities are most easily and effectively dealt with by pressing a little filler paste into them with a finger. Filler scraped on with a filling knife often fails to penetrate and fill small holes.

Cross sections of typical defects or seams requiring filling.

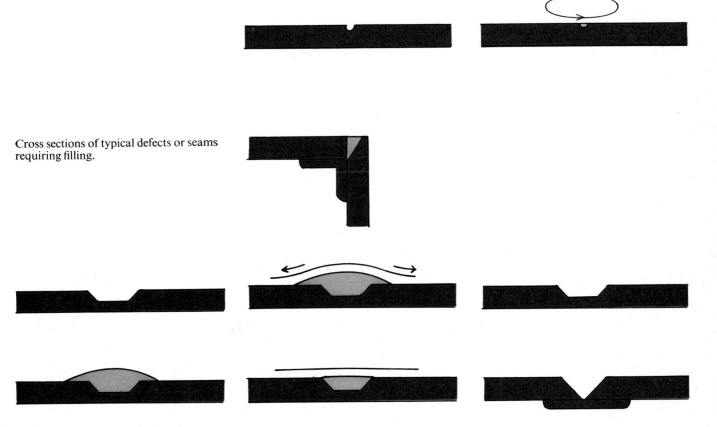

Shallow indentations

For filling shallow indentations in a flat surface, use a steel rule or other straight edge to apply filler. When clearing imperfections like this on a regular surface use a flat 'sanding block'. (It is often desirable to stick wet and dry paper to a flat piece of blockboard for this purpose. Use a contact adhesive.) If the indentation is deep (greater than $\frac{1}{8}$in.) it should be filled in several stages with a 'slow mix' of filler paste (little catalyst), as the shrinkage of the filler generally accentuates the indentation (see diagrams). Filling in several stages reduces this.

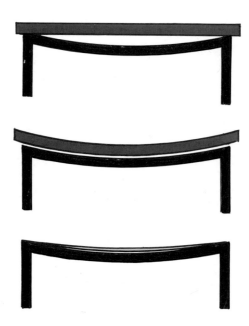

Self-coloured laminates

A special procedure is necessary for filling imperfections in a self-coloured laminate. The filler should be a mix of the original gel-coat. The hollow or cavity should be filled to excess and a sheet of acetate-cellophane pressed over it and kept in place until the resin has been cured.

It is very difficult to make any sort of repair to a self-coloured laminate without the repair showing. This is usually because particles of dirt in the cavity to be filled show up as a dark line round the filled area. Other factors, such as the inevitable difference in exotherms, contribute to the difficulty of making a perfect match. Darker, opaque colours are less critical than others in this respect. Laminates, self-coloured, with a metallic filler powder, present few of the above problems and can be quite satisfactorily filled with some of the original gel-coat mix.

The difficulty of making good a self-coloured laminate makes the process really suitable only for regular one-piece castings. For this reason most polyester/resin/glass-fibre works require painting.

Finishing methods: painting

A number of paints are suitable for use on cast polyester resin and can be applied in various ways. The following preparatory work, however, must be done whatever paint or method of application is to be used.

1. The cast must be thoroughly cured.
Partially cured resin is chemically active and will almost certainly affect the finish.
2. All release agent must be removed from the surface.
This is accomplished best by washing with warm water and rubbing the surface with an abrasive detergent powder. The cast should then be washed with clean water and allowed to dry thoroughly.
3. All holes, cracks, etc. should be filled with a resin filling compound (see Finishing methods, page 101).

Remember that paint is only a skin over the cast to colour or protect it. It is no good trying to use it as a filler to make an uneven surface smooth. A good smooth paint finish requires a good smooth cast to start with; so check that the cast has the finish required before starting to paint.

Suitable paints are those which will adhere properly. However, factors such as flexibility of the ground and desired durability have to be considered. For example, a flexible cast will require a flexible paint. And paints with no ultra-violet barrier will not do for work that is going into the open. The available method of application must also be taken into account. Here are some *general* rules for choice of paint.

Finishing methods: painting

For a high glossy, durable surface:
cellulose lacquers, acrylic lacquers, polyurethane lacquers and synthetic enamels. Various firms make specialist types of these paints. Choose one most appropriate for the job in hand. The industrial varieties, used for auto-spraying, marine woodwork and similar work, are preferable to general household enamels. Once the initial preparations have been made, follow the manufacturer's instructions regarding undercoats and so on.

For matt surfaces:
matt cellulose lacquers, matt polyurethane varnishes over either polyurethane lacquer or synthetic enamel PVA water-soluble paints. Matt surfaces are less durable than high-gloss ones, although they are often preferable for reasons of appearance. A matt polyurethane varnish applied over a compatible gloss paint provides the most durable finish. As with the gloss paints, select industrial types where possible and follow the manufacturer's instructions.

For two reasons I am reluctant to stipulate types of paints and methods of applications. The first is that the enormous range of paint finishes available, with an equally wide range of thinning proportions and so on, is constantly subject to modifications, often critical enough to affect the finish. The second reason is that most manufacturers provide comprehensive technical data for the use of their products readily understood by the layman. They are also willing to provide additional advice on which products to use. Provided their instructions are followed, they are generally prepared to help if the end result is at odds with their

prognosis. It is a good idea to foster curiosity about the suitability of various finishes. Take note of any industrial finish which seems especially durable or displays some other valuable property, and enquire about the method of application, type of paint, and so on. It may be a suitable finish for polyester resin/glass-fibre laminating

Surfacing with polyester resin

Pigmented polyester resin can be used to paint polyester resin/glass-fibre laminates. The resin is pigmented, then thinned with monomer-styrene to a sprayable consistency before catalyzing. It is then sprayed over the prepared surface. The care needed to ensure that the proportions of catalyst used will provide a 'paint' with an optimum flattening down and drying time make this a method to be initially attempted in a certain spirit of adventure. Tests must be made to ascertain the available work time and the equipment must be cleaned immediately after use, with monomerstyrene or acetone thinners. This method is dangerous and should be used only after the user has had considerable experience in handling polyester resin and then only in work areas which are models of efficient layout, with superb ventilation and extraction systems. *Consult a resin manufacturer first.*

Examples of painted finishes:

1. Sprayed gloss lacquer.

2. Hand-painted matt surface.

3. Polished cellulose lacquer.

4. Sprayed industrial hammer finish.

1

2

3

4

Cleaning up

Once polyester resin has cured it is insoluble and extremely difficult to remove. It is therefore imperative that hands, brushes, and all equipment are cleaned *before* the resin has cured. Spilt resin can be easily removed when it is in a soft gel state and resin in polythene containers can either be removed in a leather-hard cure state or flexed out when completely cured.

Cleaning up

List of solvents and their applications

Acetone: useful for removal of resin in liquid state from hands, brushes, rollers, clothes, etc.

Kerocleanse: removal of resin, liquid or soft gel, from hands, brushes. Brushes cleaned in Kerocleanse must be washed, preferably with hot water, and dried thoroughly before re-use.

Swarfega: (or similar detergent jelly + meths.) for liquid or soft gel resin from hands, brushes. Brushes should be washed and dried before re-use.

Most household detergents + hot water will be adequate for removing liquid or soft gel resins from brushes; to be really effective the water must be hot.

Cured resin on tools like metal rollers and scrapers is best burnt off over a gas flame. Douse in water when hot and dry thoroughly before re-use. During a large casting operation, brushes and rollers can be kept free of cured resin if they are immersed in acetone between mixes. They must be agitated occasionally and the acetone must not be allowed to become 'resin rich'. If curing has begun this method is not satisfactory, as acetone does not stop it. Methylated spirits can be similarly used.

Making sculpture direct

Most laminating processes can be used to fabricate sculpture without resorting to casting from a positive in some other material, such as clay, plaster or wax. Laminates cast from a flat casting surface (see page 30, and Making the mould, page 32), can be used in conjunction with the joining methods described to produce a variety of forms. Curved surfaces can be fabricated using rolled sheet metal casting surfaces. The possibilities are quite numerous; but a disadvantage is that the method offers little opportunity for the user to change or vary the form during fabrication. Another method, which obviates this difficulty, involves the use of expanded polyurethane foam (see Reinforcing methods, page 82). This material, available in a variety of densities, is easily shaped, cut and joined. Covered with glass-fibre/polyester resin laminate it has great structural strength and is an ideal material for making sculpture direct. The procedure, for making regular or irregular shapes, is in five steps as follows:

1. Select a block of foam of medium density and form it to the desired shape. This can be done by rasping with a surform, rubbing with coarse wet or dry or similar abrasive. To minimize waste and reduce the amount of shaping necessary the foam can be cut into various sizes and glued into an approximation of the shape required with a rubber contact adhesive, such as Evostick.

2. When the form is complete, assess roughly its surface area and pre-cut as many 4in. squares of chopped strand mat as are necessary to cover it. Using normal hand lay-up methods of laminating, apply one laminate over its surface as evenly as possible. Bear in mind that this process is the

reverse of normal casting procedure as far as the position of the 'good side' goes. When this laminate has cured, the shape will be structurally complete. The remaining processes are all directed toward giving it the required finish. For the purpose of explaining how this might be obtained, I shall assume that the required finish is smooth and free from surface irregularities, texture, etc.

3. At this stage there are two alternatives: *either* to apply a further laminate using surface tissue instead of chopped strand mat, *or* to apply a gel-coat mix of resin evenly over the surface. Either method will 'close the surface' to produce a finer, more regular texture.

4. When this step is complete and the resin cured, the shape can be finished by normal finishing methods, that is, rubbed down with various grades of wet/dry paper, coarse/fine. Using pigmented resin throughout, it is possible to obtain quite satisfactory self-coloured results. However, to ensure an even surface it is necessary to apply two or more coats of gel-coat resin after the laminates have been applied. This doubling-up may be required when not making a self-colour job, if the laminates have not been applied evenly enough.

5. Additions or alterations to the shape when complete can be made simply by repeating the process on the areas where change is required. If an area is to be removed, it can be cut away and re-laminated. If something needs to be added it can be grouted in by cutting away the surface to expose the foam in the area to be extended. More foam can be glued in place, shaped and laminated, welding the addition into the original form.

Checklist for faults

Fault	Cause	Correction if possible
Gel coat not setting	No catalyst	Catalyze a mix of laminating resin heavily and scumble gently in with the gel
	Damp mould Damp filler Extremely low ambient temperature	Apply heat
Gel coat only taking on slight set	As above	Generally the only thing to do is continue laminating with caution so as to disturb the gel coat as little as possible – the exothermal heat from the greater bulk of the laminate will ensure a set – if this is not possible and the mould is a simple one the gel may be stripped out
Laminate not setting	No catalyst	Remove and apply fresh laminate with catalyzed resin
	Low ambient temperature	Apply heat
Laminate remaining tacky on back	Over catalyzed Over pigmented	Either apply a thin coat of well catalyzed resin or wash with acetone

Checklist for faults

Fault	Cause	Correction if possible
Gel tacky on surface of cast	Damp mould Damp filler Absorbant mould not properly sealed – this means monomer styrene will have been sucked out of gel Release agent not properly dry	Application of heat may help, otherwise cast should be washed with acetone
Wrinkles in gel on surface	Gel too thin Laminate applied too soon	Use filler paste
Blister	Laminate not properly impregnated Moisture on gel Partial set due to damp brush or uneven mixing of resin and catalyst	Cut out blister and fill
Pin holes in surface of cast	Gel put down unevenly Gel not allowed to stand after compositional mix	Filler paste or paint stopper
Dry laminate	Not impregnated properly Resin drained from steep surfaces	Use a slightly thixotropic laminating resin
Soft patches in cast	Probably due to dry laminate trapped between gel and subsequent laminations	Cut out and use filler

Checklist for faults

Fault	Cause	Correction if possible
Cracking and crazing of gel	Over catalyzed/over heated resulting in over rapid cure	Filler
Uneven colour in pigmented casts	Unevenly applied gel and uncoloured laminate Badly mixed gels	Generally the effect can be minimized if the back of the cast is given a coat of well pigmented resin or simply painted the required colour
Adhesion preventing withdrawal from mould	Mould fault – undercut etc.	Waste moulds present no problem
	Damp mould Patchy separator	Sometimes warm water eased in between cast and mould effects a separation
Paint not adhering properly	Trace of separator Cast not properly cured	
	Trace of silicone wax present	Silicone may be added to the paint in some cases to overcome this problem, otherwise the only treatment is to remove paint and ensure that mould is clean, dry, and sufficiently roughened to accept the paint

Getting the best results

Best results are always achieved and faults most easily corrected if the user manages to work in an orderly fashion taking care at every stage. It is worth keeping track of pieces executed in resin and glass-fibre as frequently faults do not become apparent immediately and though not always the case a few years is not a long time in the life of a piece of sculpture and most of the techniques described can be adapted to effect repairs. Every so often new products for use with resin and/or glass-fibre come on the market – the best way to keep abreast of these developments is through the manufacturers; most large concerns publish trade journals or technical information sheets. A letter to them stating one's interest is generally enough to ensure the receipt of all further news of their products.

British suppliers

This list does not attempt to be comprehensive. Prospective users of the materials described in this manual are advised first to contact suppliers of the complete range of materials and equipment.

General filler pastes suitable for resin and glass fibre work are available from motor body repair specialists and may be used with confidence.

Strand Glass Co. Ltd
Brentway Trading Estate
Brentford, Middlesex
All materials and equipment

K. & C. Mouldings Ltd
Spa House
Shelfanger
Diss, Norfolk
All materials and equipment

B.I.P. Ltd
British Industrial Plastics
Popes Lane
Aldbury
Warley, Worcs
Resins and mat

Trylon Ltd
Thrift Street
Woolaston
Wellingborough
All materials and equipment

Alec Tiranti Ltd
72 Charlotte Street
London W1
All materials and equipment

Fibreglass Ltd
Valley Road
Birkenhead
Glass fibre, all makes and descriptions

Ciba Ltd
Duxford
Cambridge
Epoxy resins

Llewellyn Ryland Ltd
Haden Street
Birmingham 12
Paints and pigment dispersions in resin

Elastomar Products Ltd
King Street
London W6
Polyurethane foam

Dufaylite Developments Ltd
Cromwell Road
St Neots
Huntingdonshire
Expanded paper honeycomb

U S suppliers

In the U S, look in your local classified directory under Plastics or Boat Equipment and Supplies or write to:

Resin Coatings Corporation
14940 N.W. 25 Court
Opa Locka, Florida 33054

Polyproducts Corporation
Order Department, Room 25
13810 Nelson Avenue
Detroit, Michigan 48227

In Canada, write to:

Waldor Enterprises Limited
(division of Ren Plastics, Inc.)
131 Hymus Blvd.
Montreal 730, Quebec
or
2580 Wharton Glen Avenue
Mississauga, Ontario